Impressionist Art
Masterpieces to Color
60 Great Paintings from Renoir to Gauguin

Rendered by
Marty Noble

Dover Publications, Inc.
Mineola, New York

INTRODUCTION

Have you ever wanted to create a memorable work of art? With this unique collection of Impressionist paintings, now art lovers of all ages can experiment by altering the colors and hues of some very well-known masterpieces of art. Included here are sixty black-and-white line renderings of artistic treasures by some of the greatest Impressionist artists in history, among them Monet, Cassatt, Pissarro, Degas, and van Gogh.

To color these magnificent paintings, aspiring artists may use watercolors, crayons, markers, acrylics, felt-tip pens, or any other type of media. Color renditions of the original works are featured on the covers of this book if you want to reproduce the artist's colors. Just remember that there is no right or wrong way to color these artworks. Explore your own creativity by mixing different styles and artists. Why don't you try to mimic van Gogh's bold brushstrokes on a different painting and see what happens? Or, change the color and tone of Derain's *La Danse* to see how it affects its interpretation.

These plates are printed on one side only, so dark markers and paints will not show through. While you're working, you may also want to slide a piece of cardboard between the pages so that the colors won't bleed. The pages have been perforated for easy removal and framing. The paintings are arranged alphabetically by artist. A section of brief notes about each artist begins on page 121.

Bibliographical Note

Impressionist Art Masterpieces to Color is a new work, first published by Dover Publications, Inc., in 2007.

International Standard Book Number
ISBN-13: 978-0-486-45135-0
ISBN-10: 0-486-45135-6

Manufactured in the United States of America
Dover Publications, Inc., 31 East 2nd Street, Mineola, N.Y. 11501

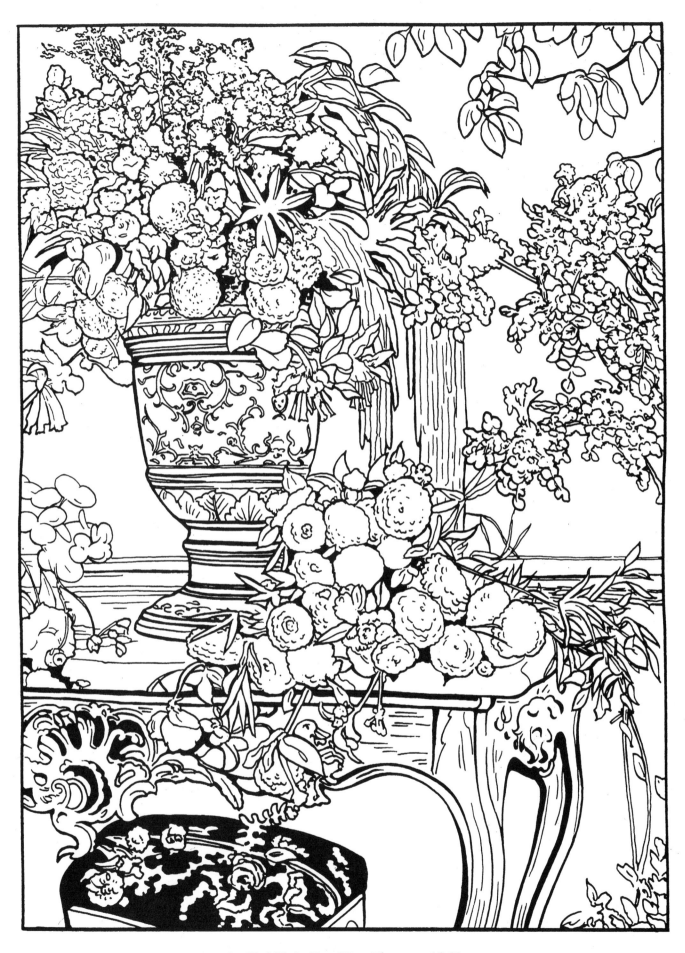

1. **Frédéric Bazille.** *Flowers,* 1868.

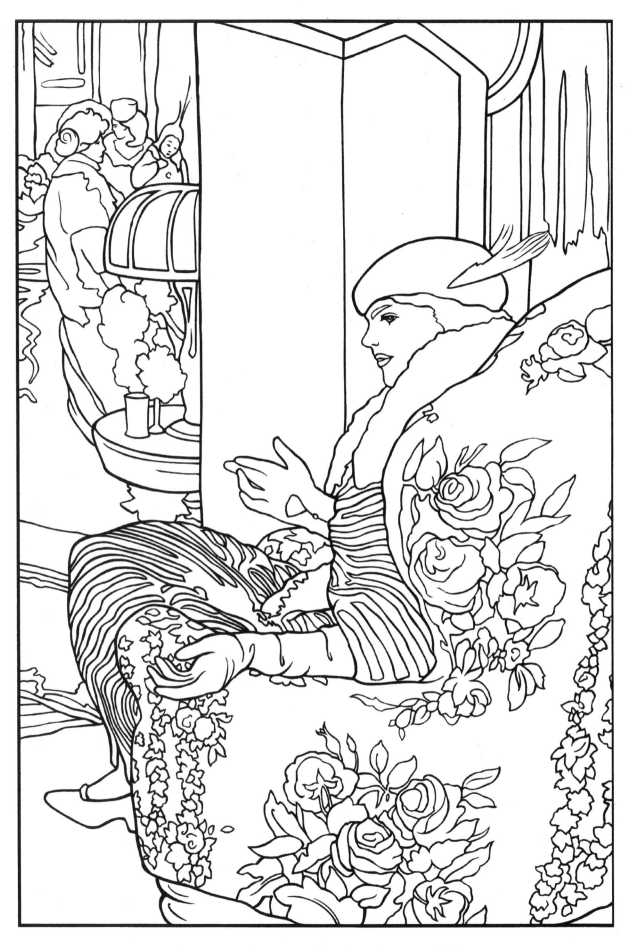

2. **Cecilia Beaux**. *After the Meeting*, 1914.

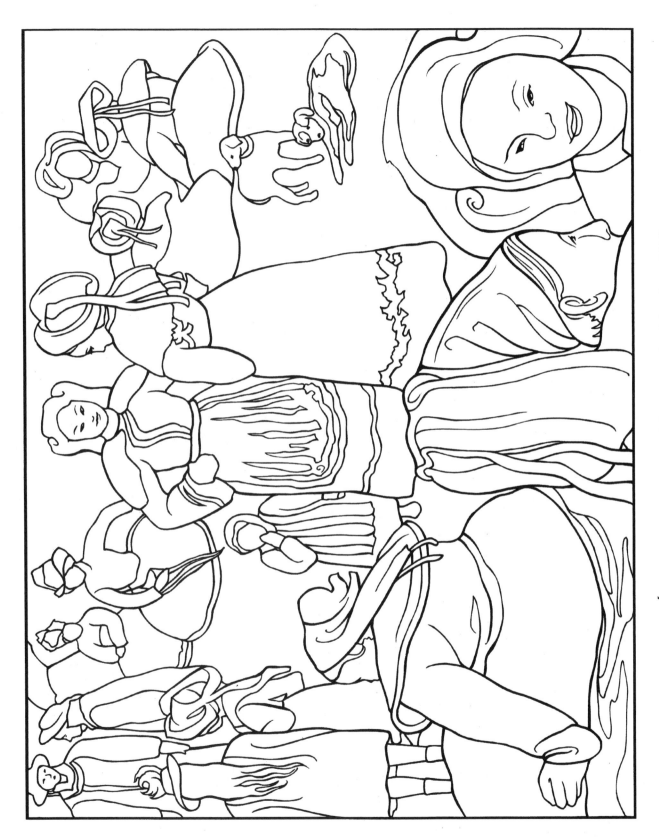

3. **Émile Bernard.** *Breton Women in the Meadow,* 1888.

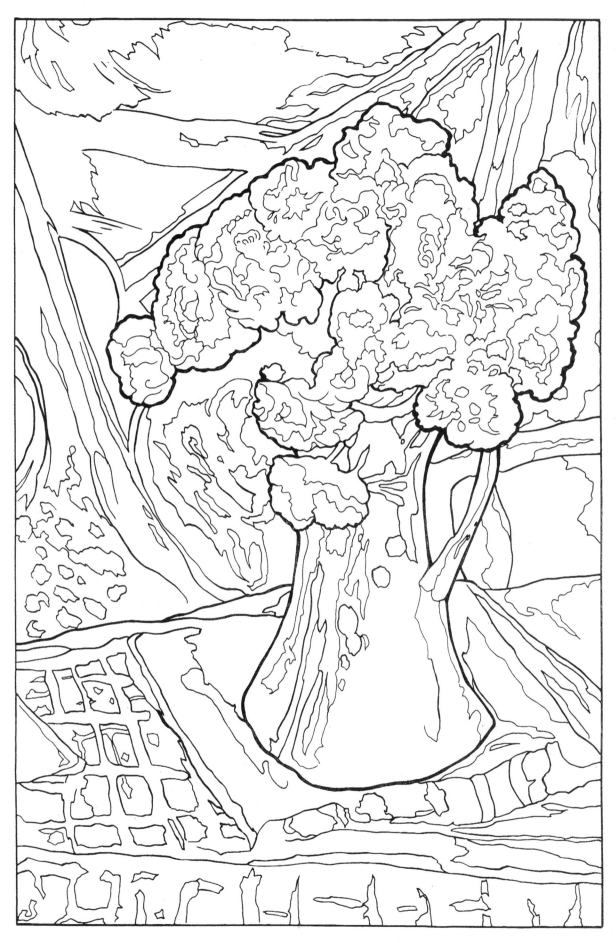

4. **Pierre Bonnard.** *Bouquet of Flowers,* c. 1926.

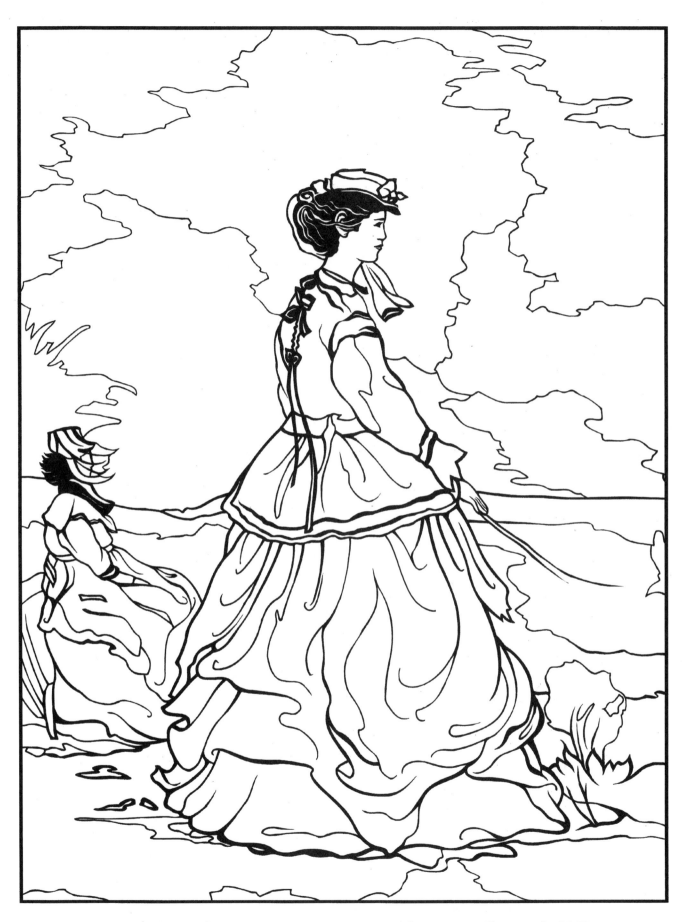

5. **Eugène Louis Boudin.** *Princess Metternich on Trouville Beach,* 1869.

6. **Gustave Caillebotte.** *Oarsmen*, 1877.

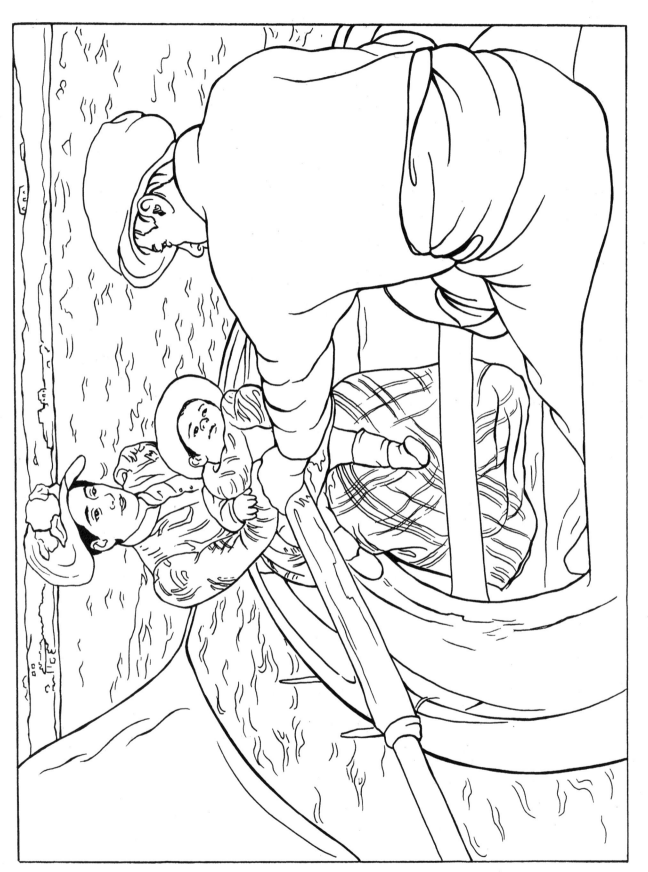

8. **Mary Cassatt.** *The Boating Party,* 1893–94.

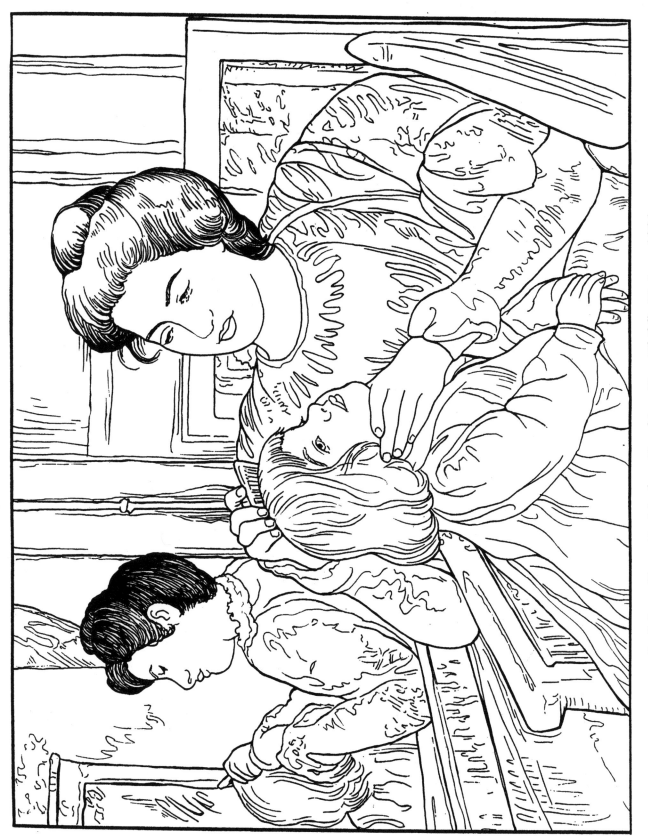

9. **Mary Cassatt.** *Mother Combing Her Child's Hair,* c. 1901.

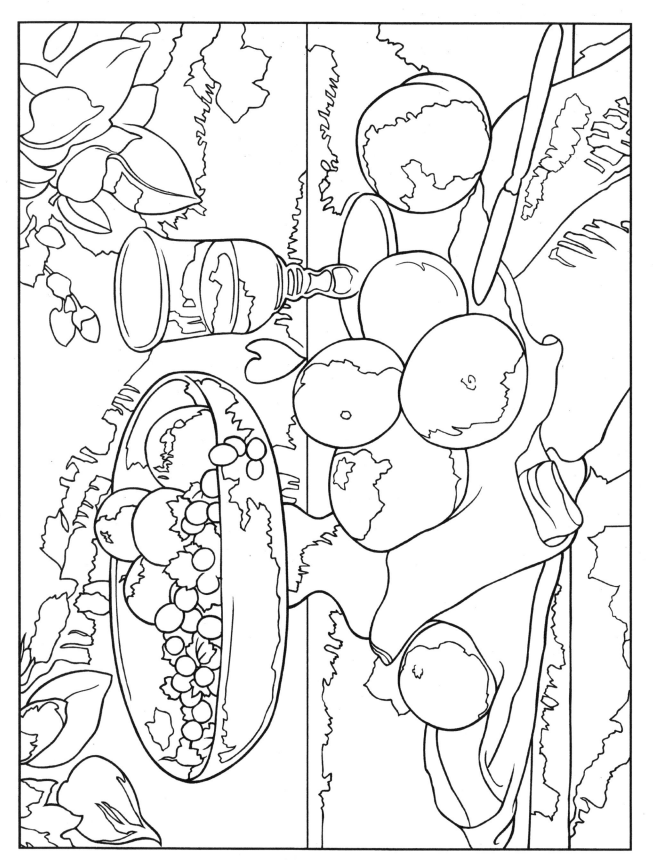

10. **Paul Cézanne**. *Still Life with Compotier, 1879–82.*

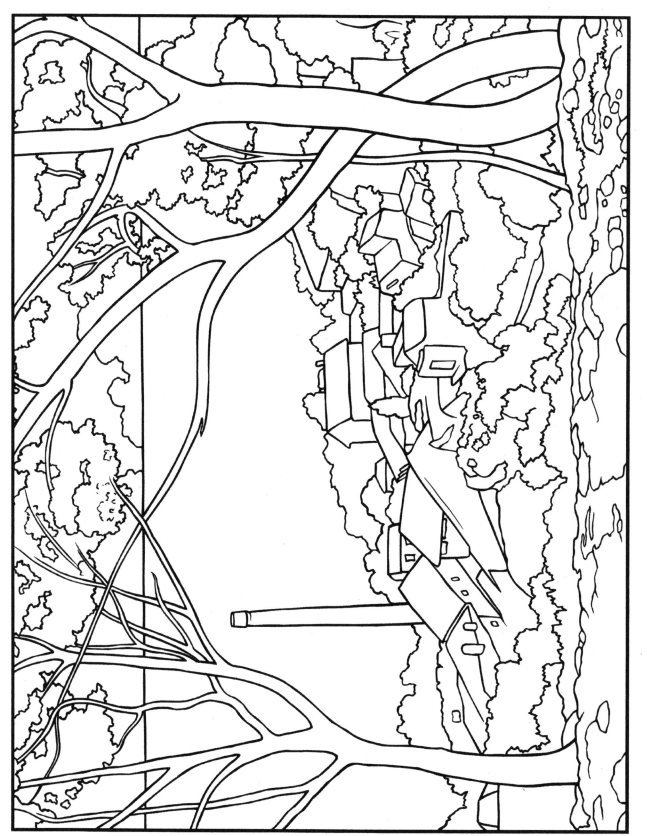

11. **Paul Cézanne.** *The Sea at L'Estaque, 1883–86.*

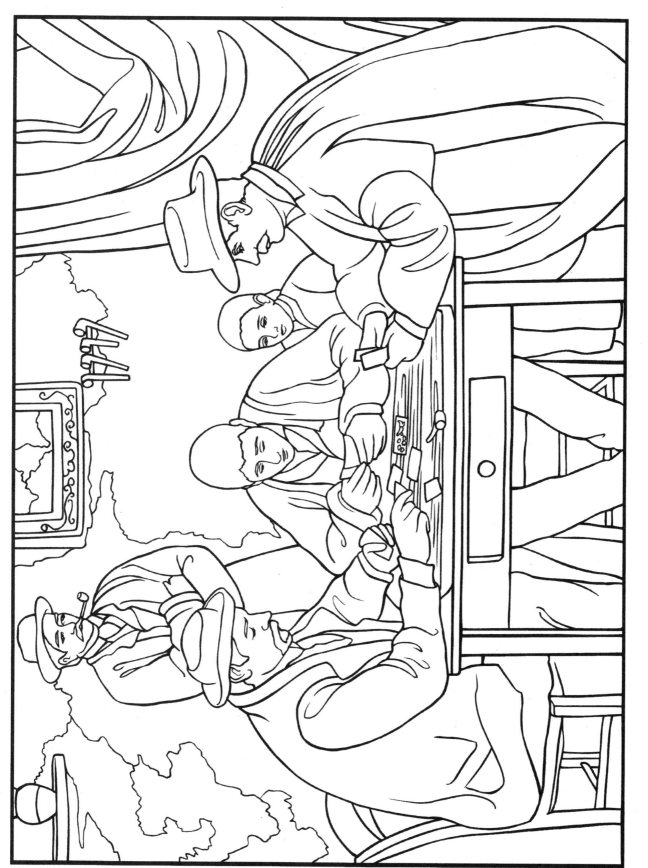

12. **Paul Cézanne.** *The Cardplayers,* 1890–92.

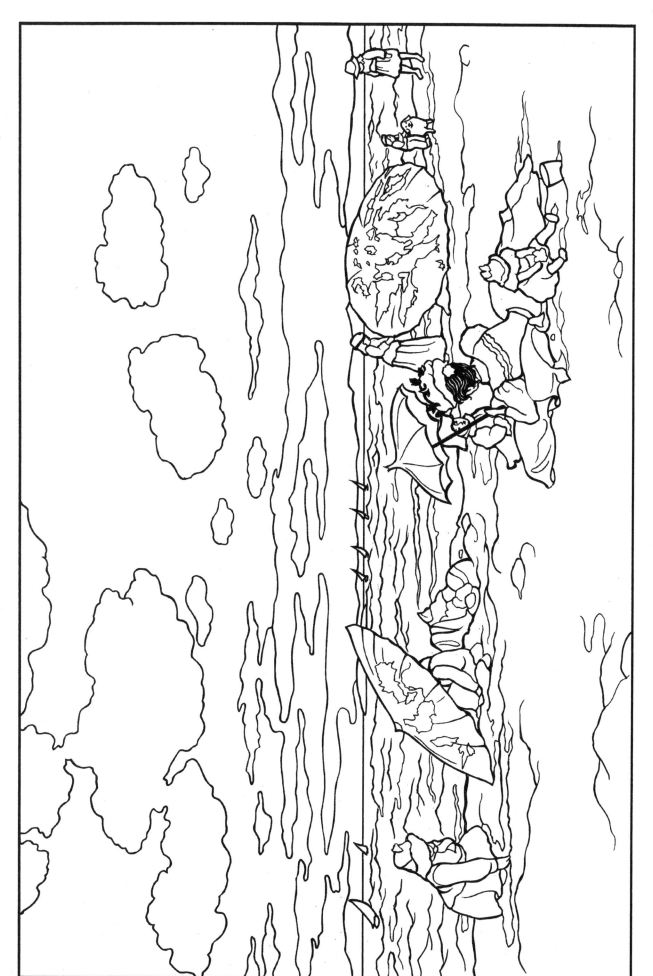

13. **William Merritt Chase.** *At the Seaside*, 1892.

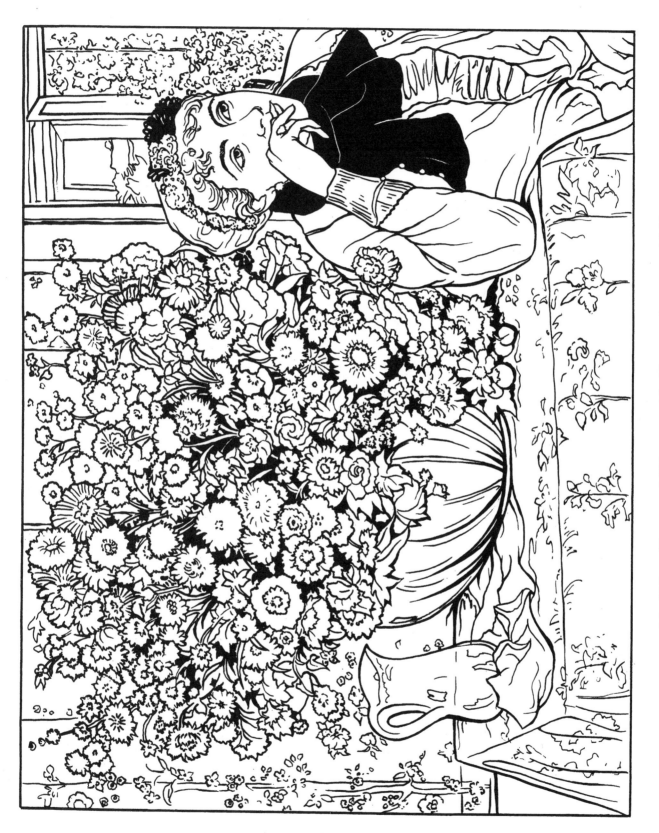

14. **Edgar Degas.** *A Woman with Chrysanthemums,* 1865.

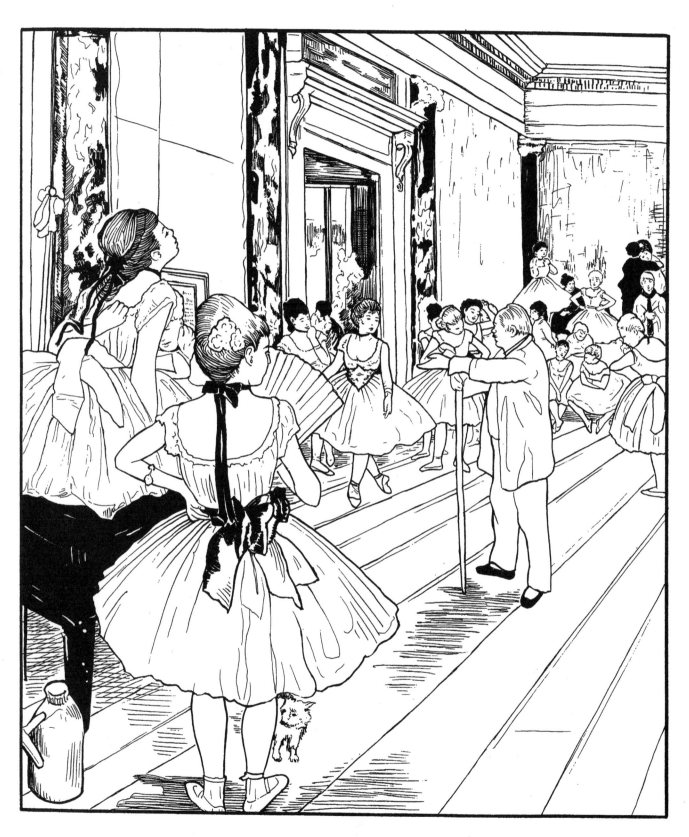

15. **Edgar Degas.** *Monsieur Perrot's Dance Class,* c. 1875.

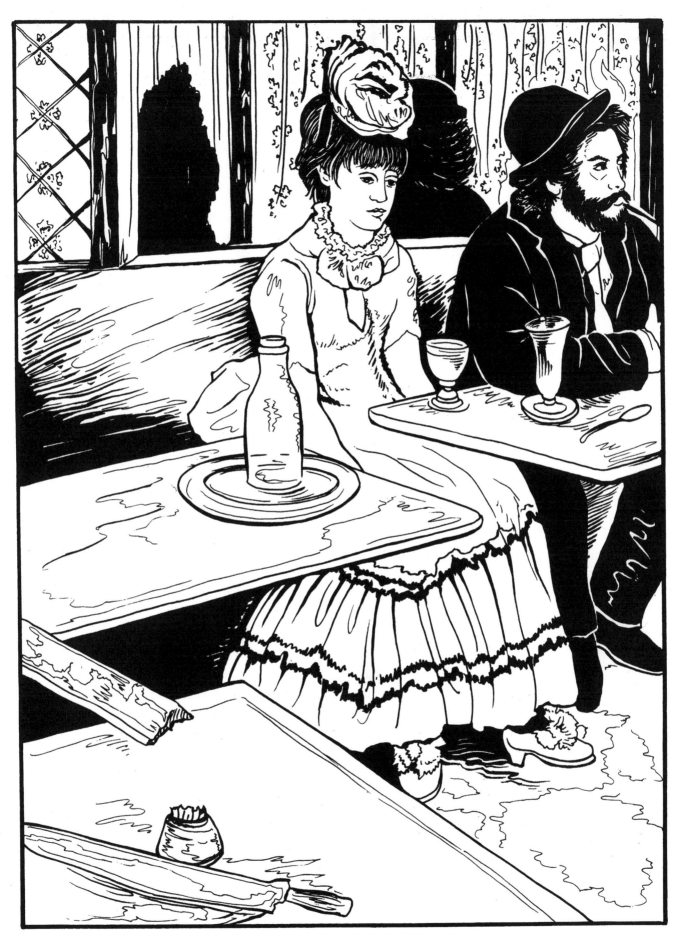

16. **Edgar Degas.** *The Absinthe Drinker,* 1876.

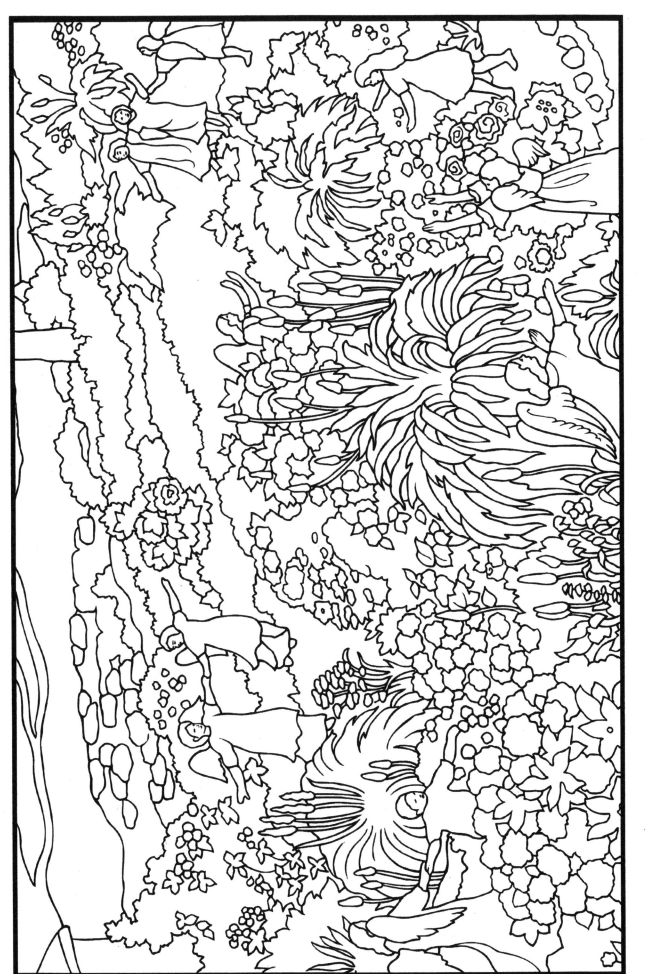

17. **Maurice Denis.** *Paradise*, 1912.

18. **André Derain.** *La Danse*, 1906.

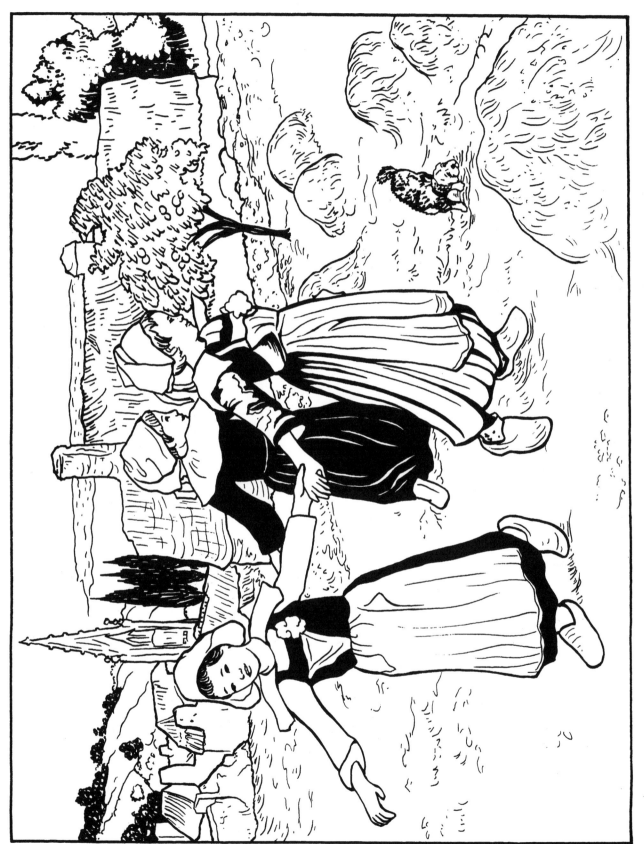

19. **Paul Gauguin.** *Breton Girls Dancing, Pont-Aven,* 1888.

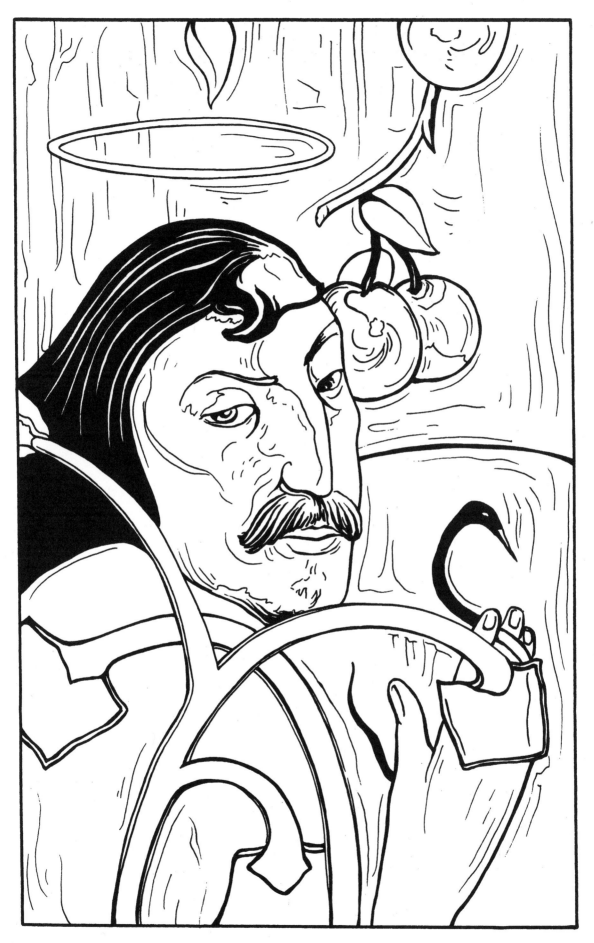

20. **Paul Gauguin.** *Self-Portrait with Halo,* 1889.

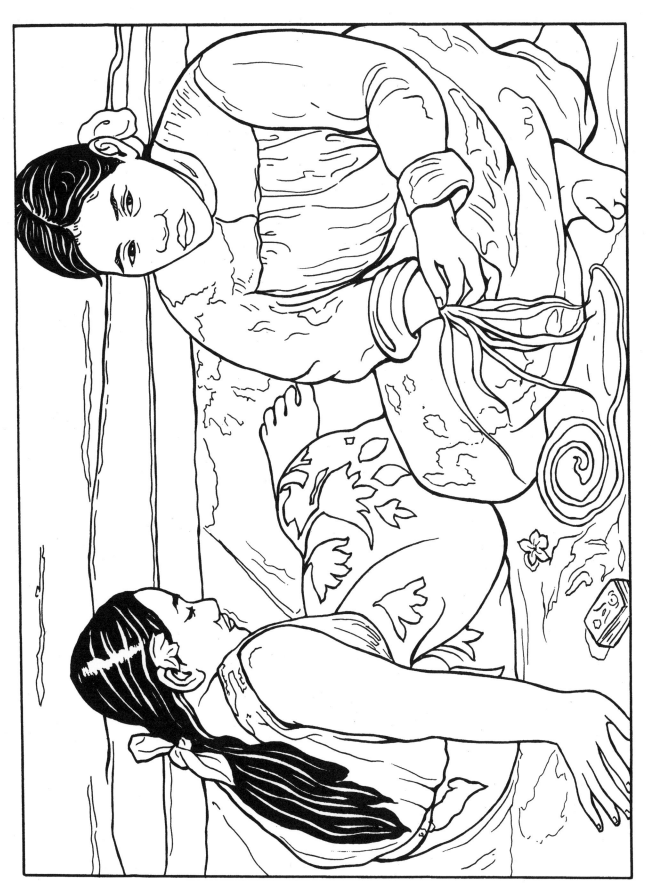

21. **Paul Gauguin.** *Tahitian Women (On the Beach)*, 1891.

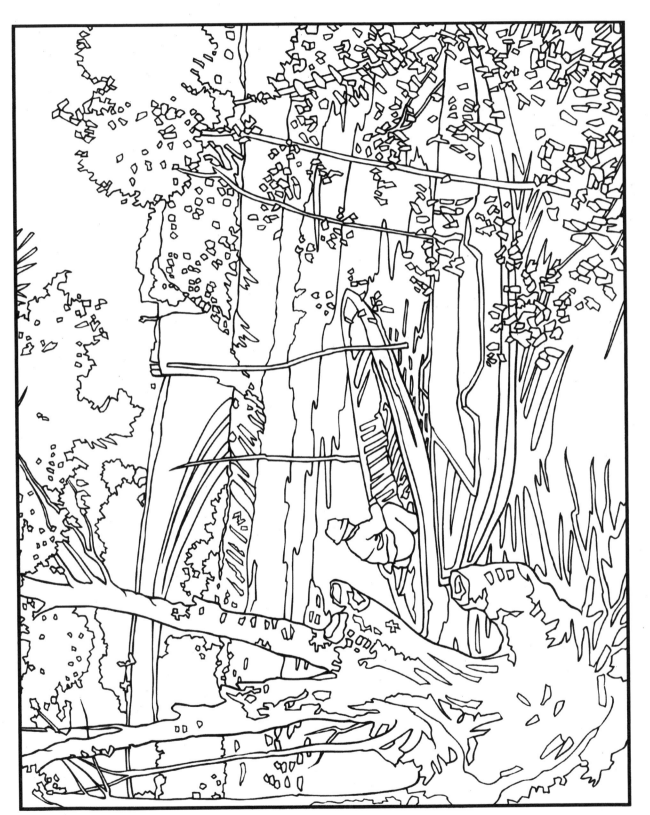

22. **Vincent van Gogh.** *Fishing in the Spring, Pont de Clichy, 1887.*

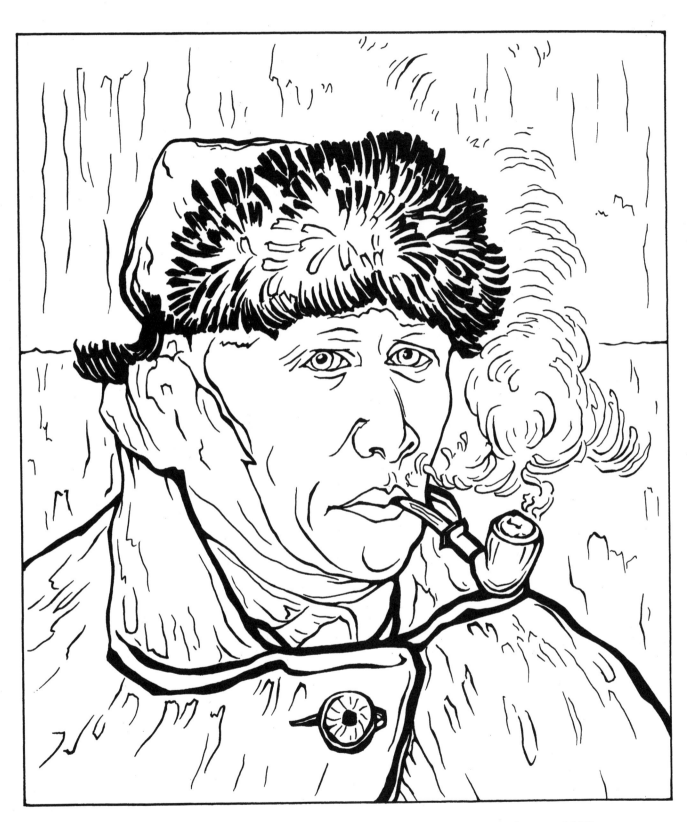

23. **Vincent van Gogh.** *Self-Portrait with Bandaged Ear and Pipe*, 1889.

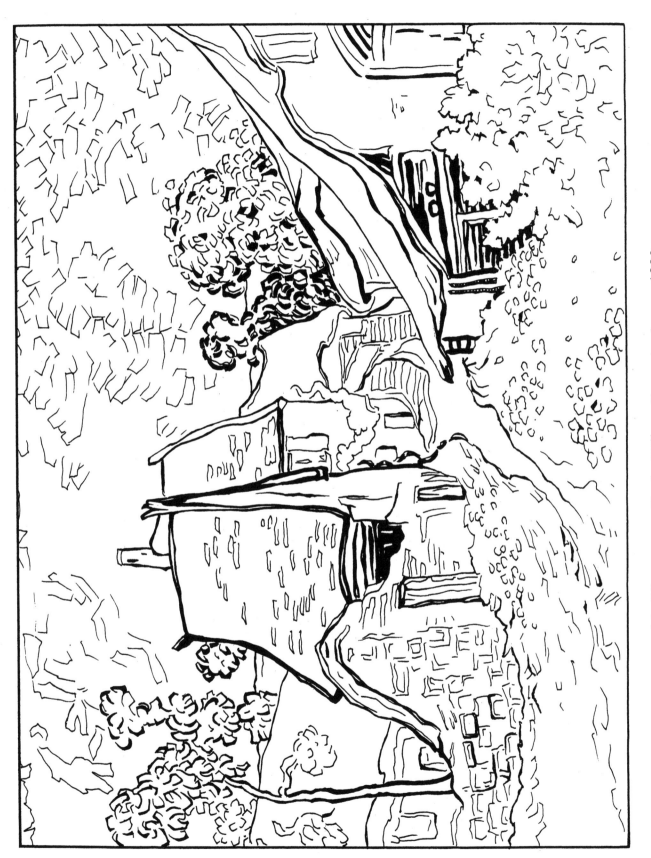

24. **Vincent van Gogh.** *Village Street in Auvers,* 1890.

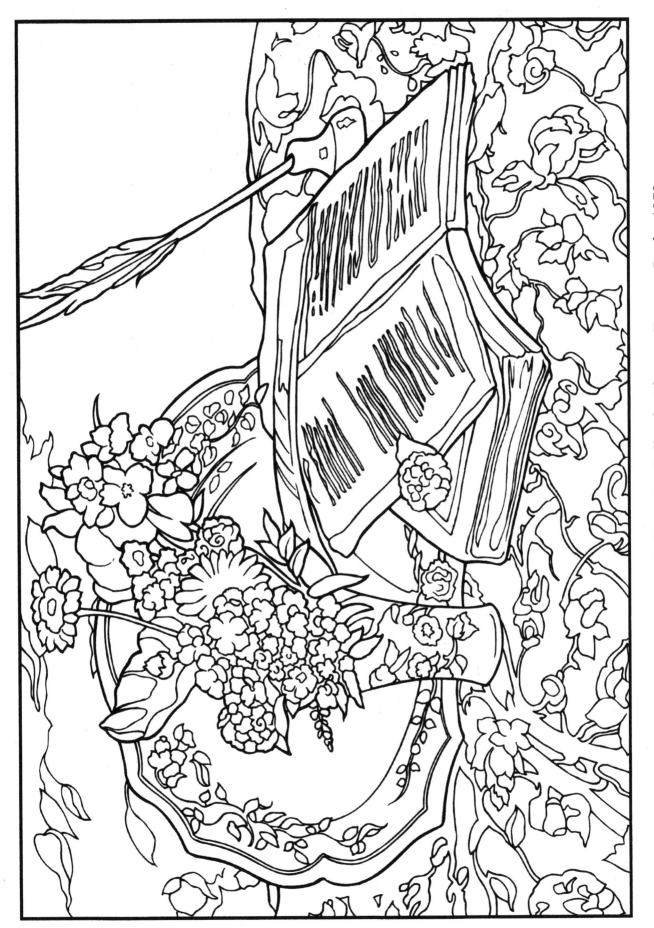

25. **Jean-Baptiste Armand Guillaumin.** *Still Life; Flowers, Faïence, Books, 1872.*

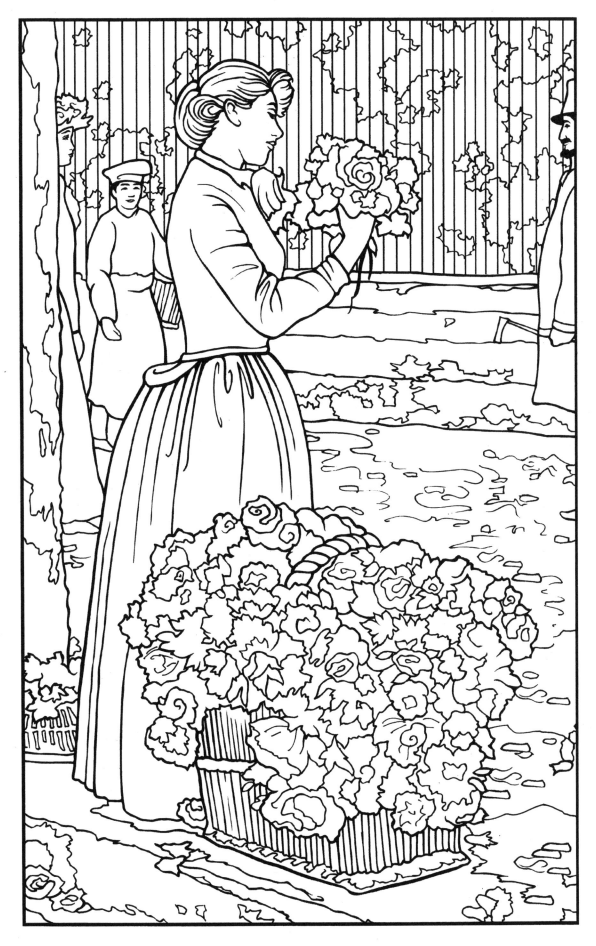

26. **Childe Hassam.** *Flower Girl*, 1888.

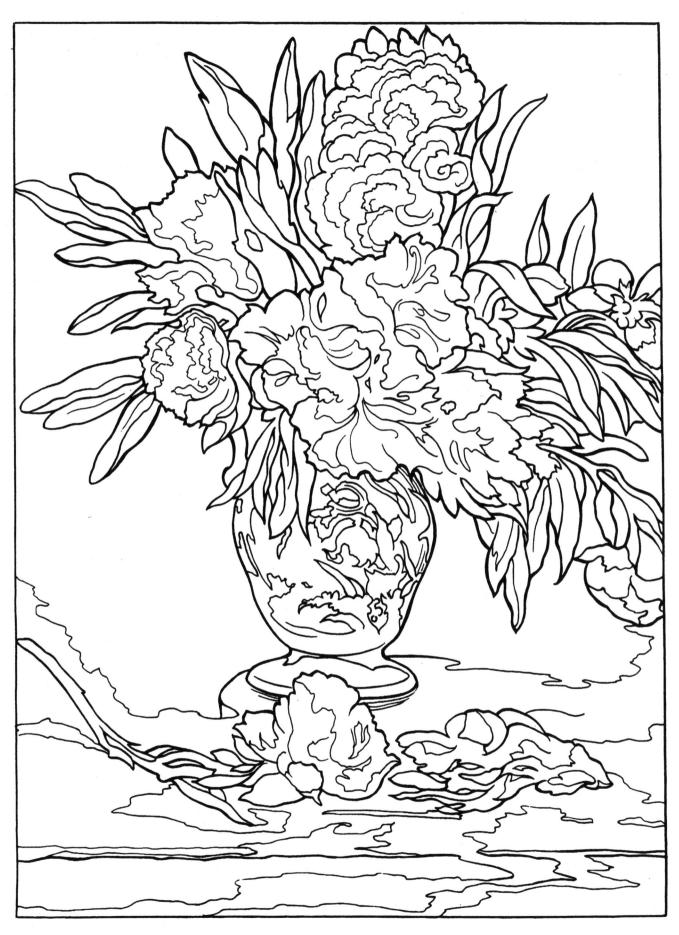

27. **Édouard Manet.** *Peonies in a Vase on a Stand,* 1864.

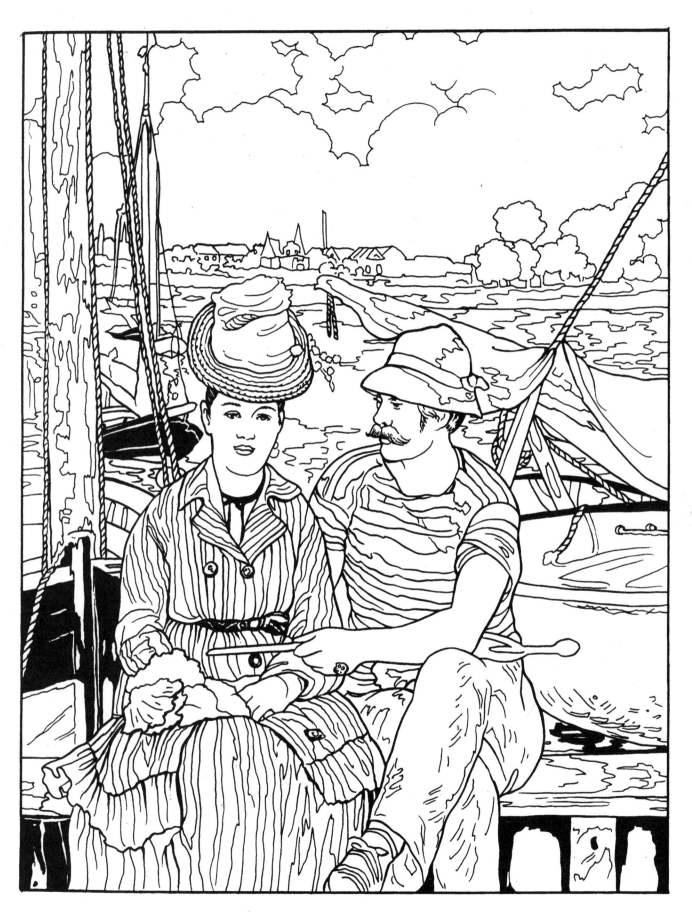

28. **Édouard Manet.** *Argenteuil,* 1874.

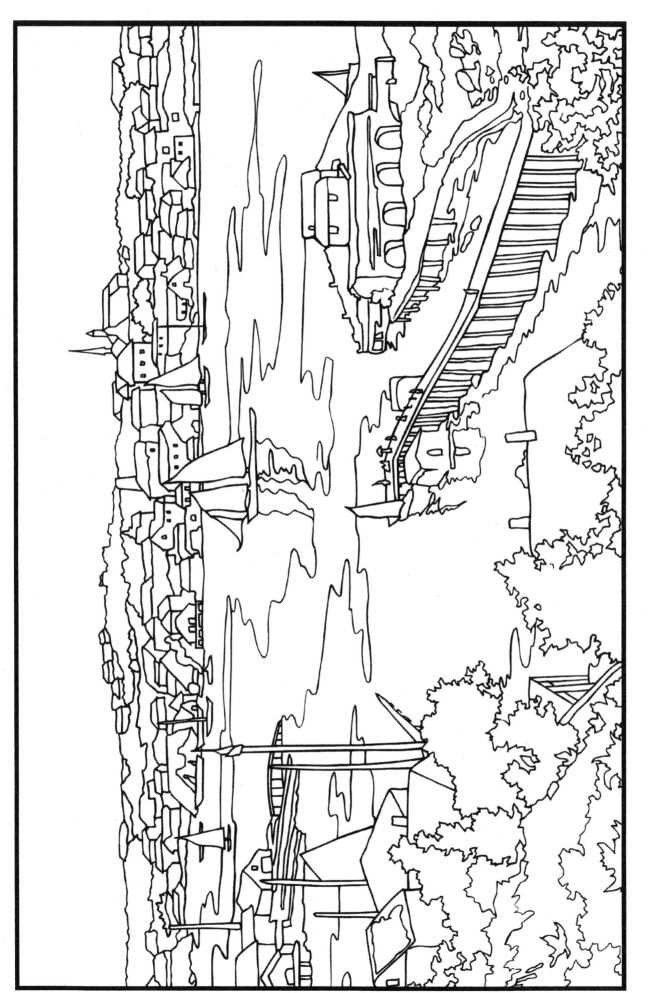

29. **Willard Metcalf.** *Gloucester Harbor, 1895.*

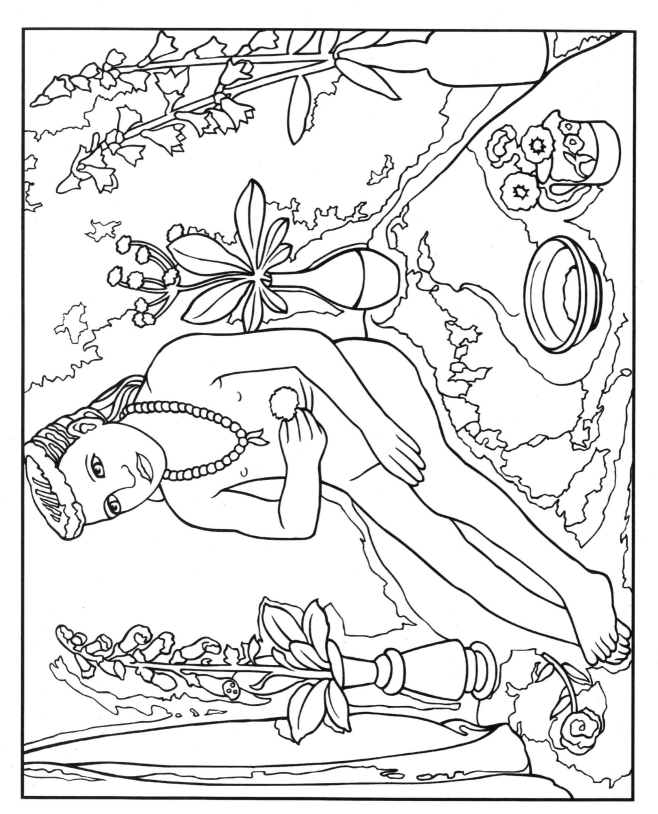

30. **Paula Modersohn-Becker.** *Seated Naked Girl with Flowers, 1907.*

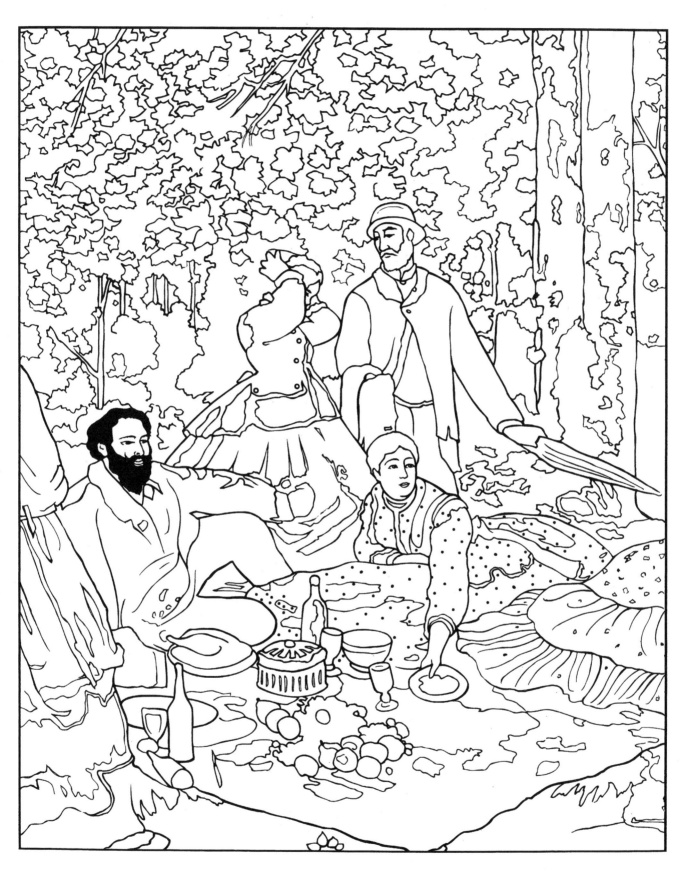

31. **Claude Monet.** *Le Déjeuner sur l'herbe (Luncheon on the Grass)*, 1865–66.

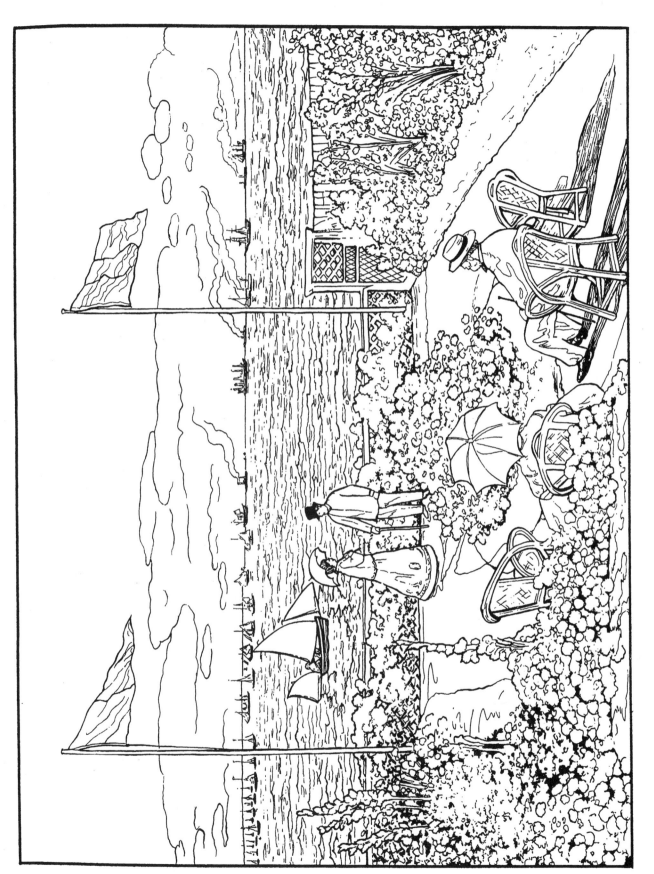

32. **Claude Monet.** *Terrace at Sainte-Adresse,* 1867.

33. **Claude Monet.** *Water Lilies I*, 1905.

34. **Berthe Morisot.** *Hide and Seek, 1873.*

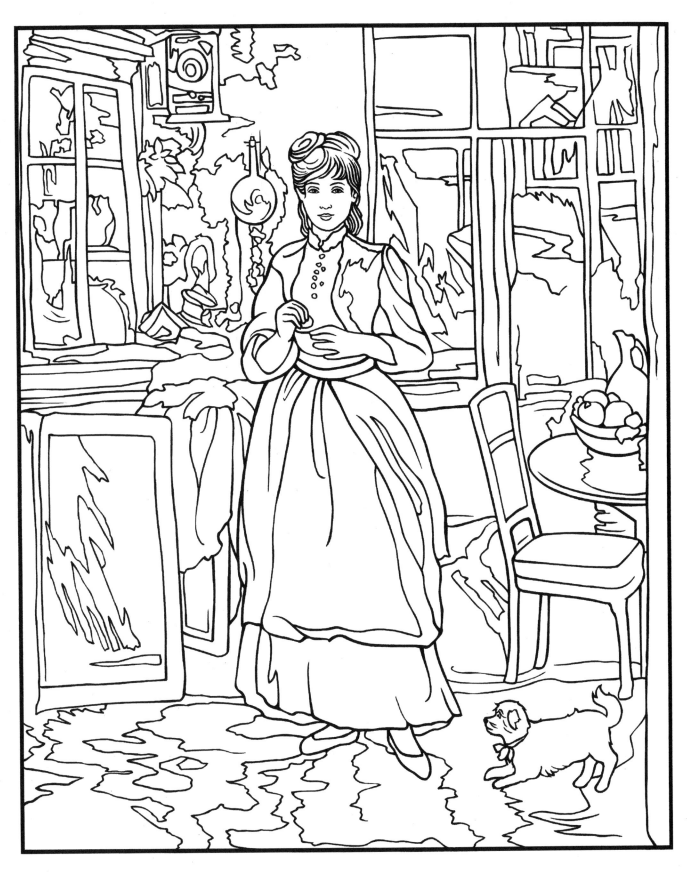

35. **Berthe Morisot.** *In the Dining Room,* 1886.

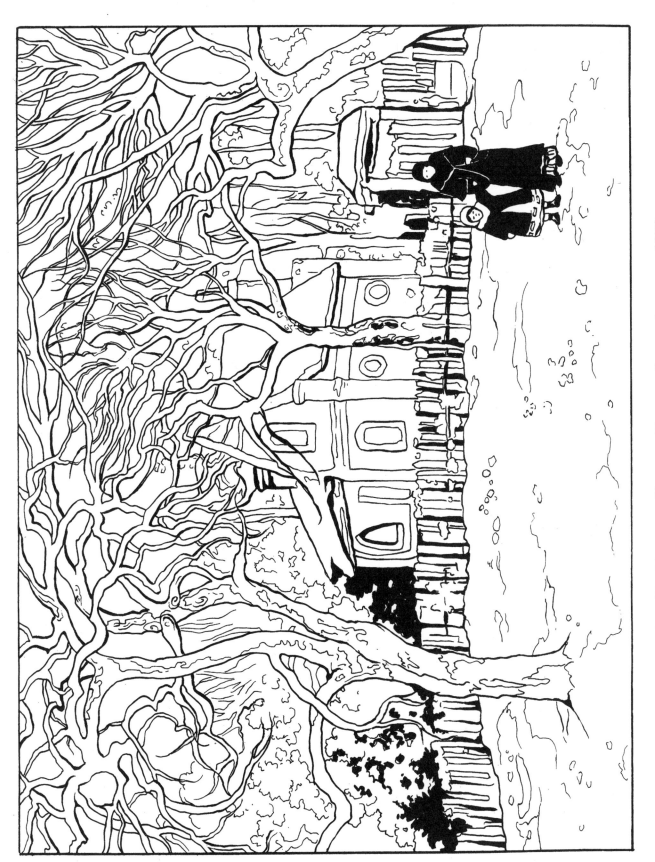

36. **Camille Pissarro.** *Chestnut Trees at Louveciennes,* c. 1872.

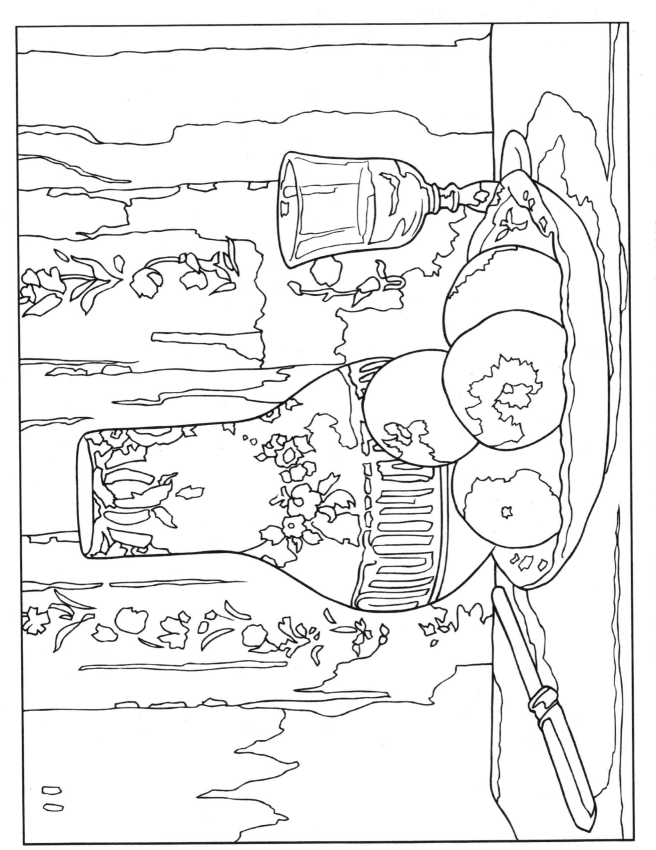

37. **Camille Pissarro.** *Still Life with Apples and Pitcher, 1872.*

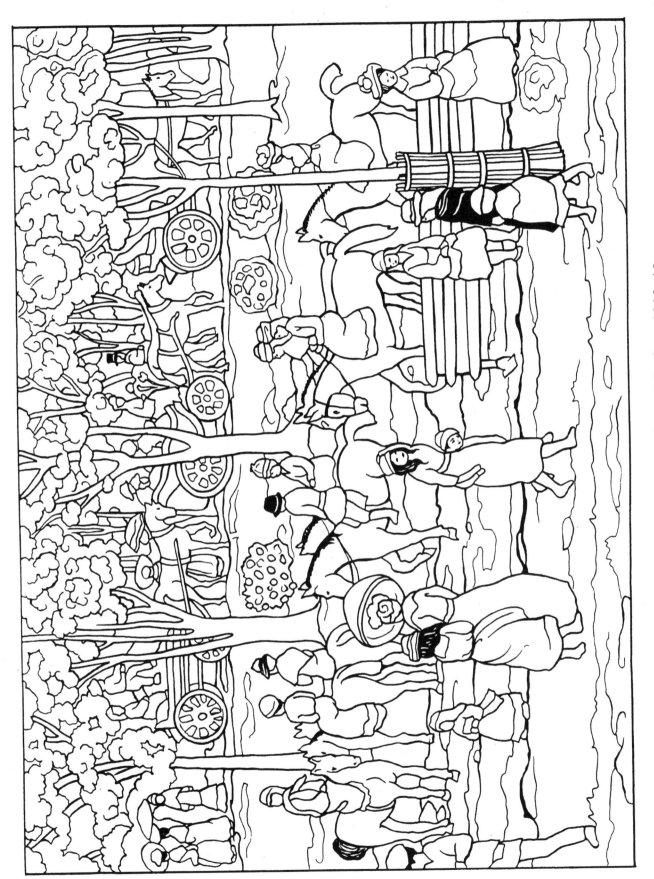

39. **Maurice Prendergast.** *Central Park,* c. 1908–10.

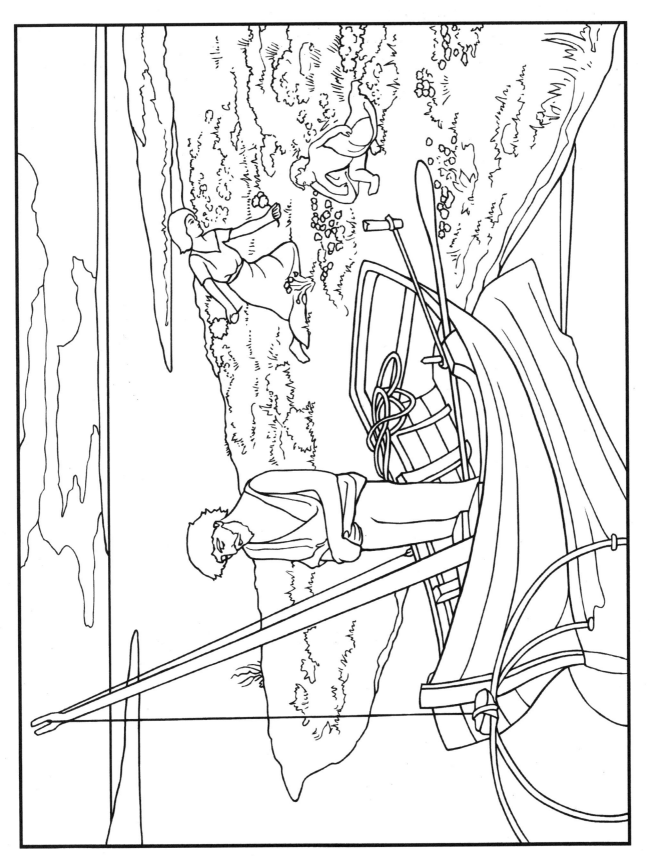

40. **Pierre Puvis de Chavannes.** *The Poor Fisherman,* 1881.

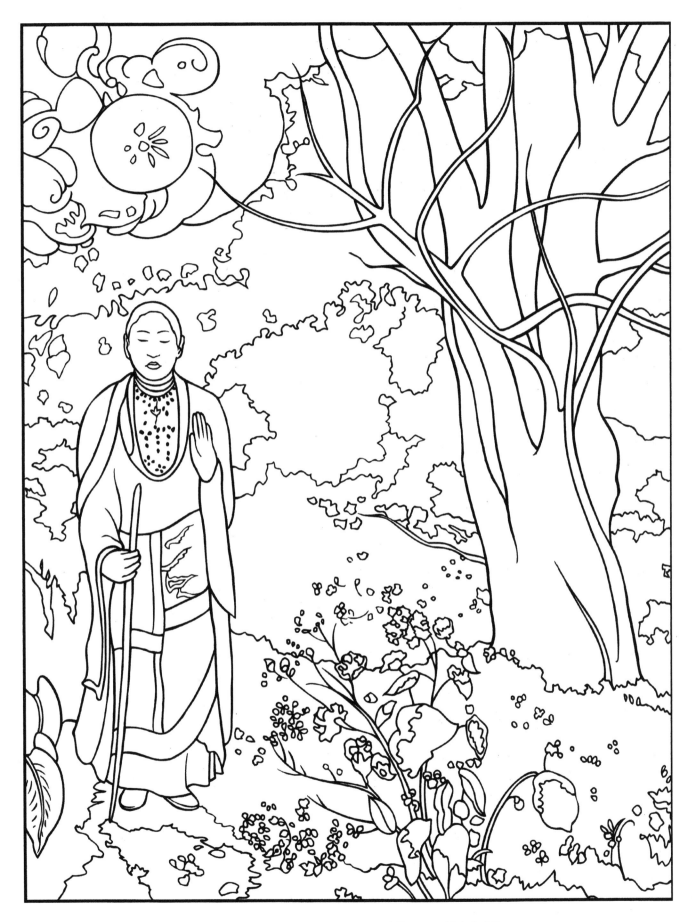

41. **Odilon Redon.** *The Buddha,* c. 1906–07.

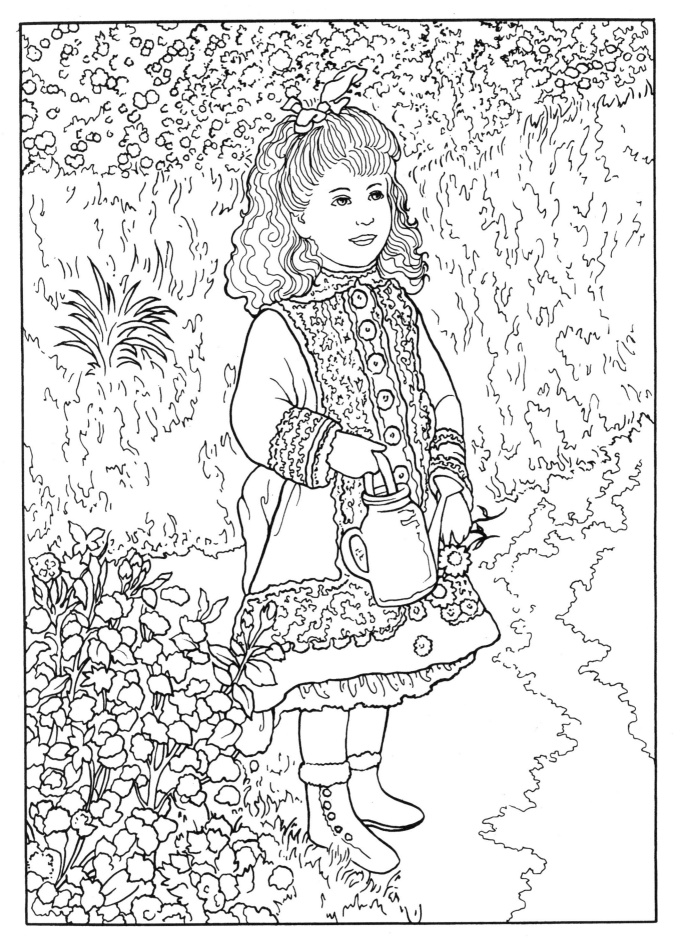

42. **Pierre-Auguste Renoir.** *Girl with a Watering Can,* 1876.

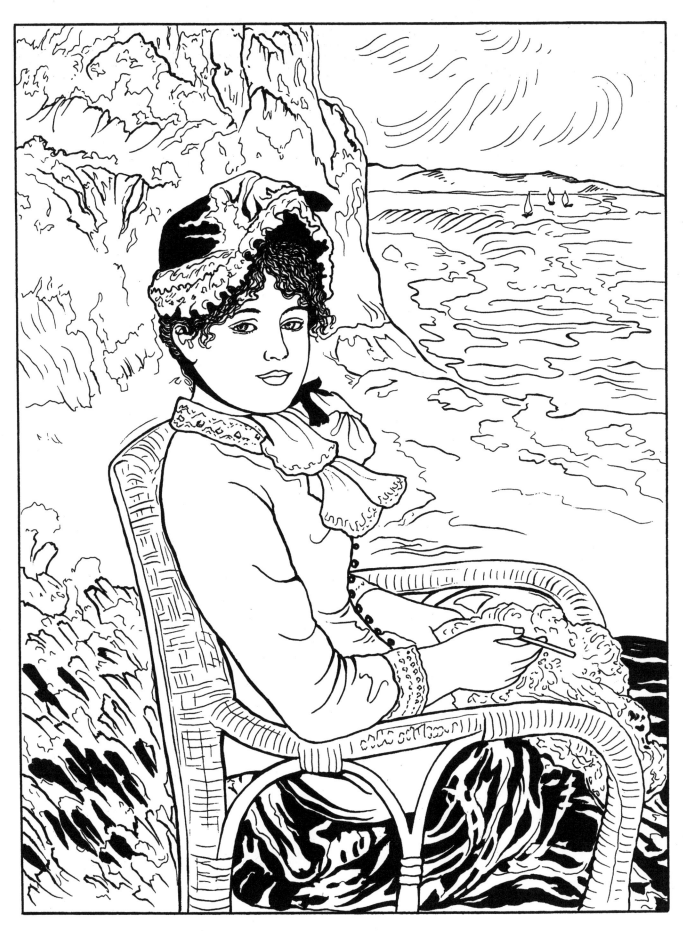

43. **Pierre-Auguste Renoir.** *By the Seashore,* 1883.

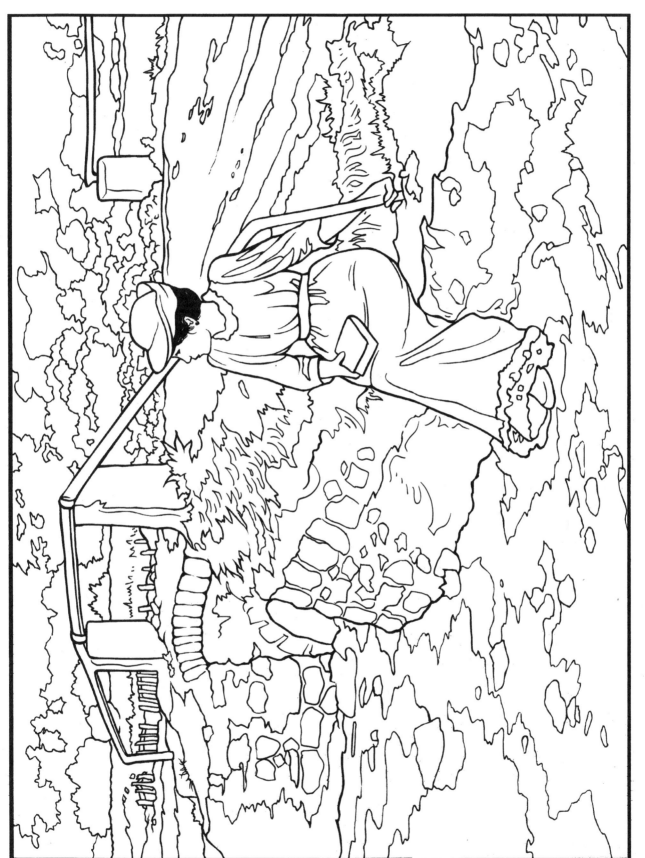

45. **Theodore Robinson.** *La Débâcle,* 1892.

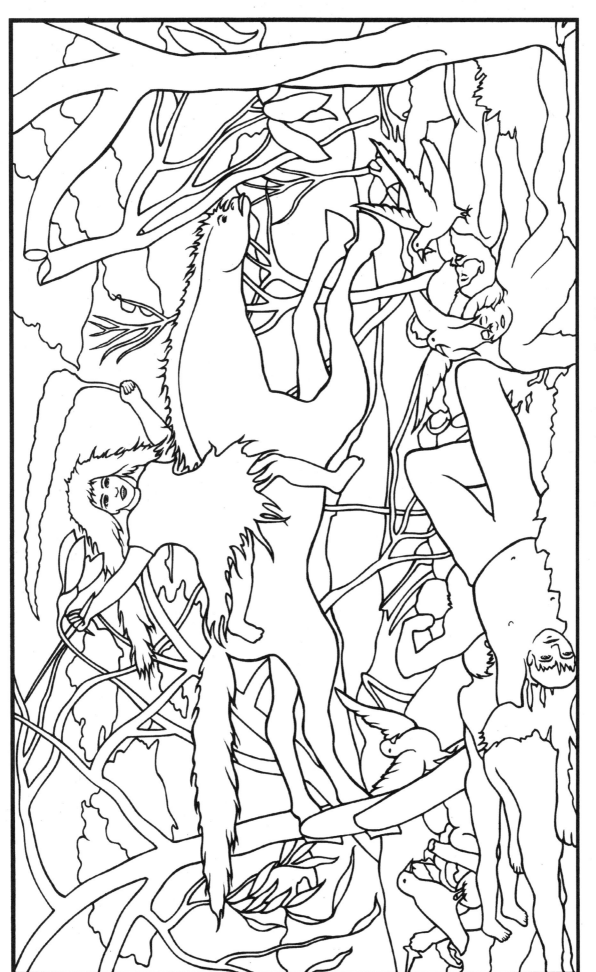

46. **Henri Rousseau.** *War (Cavalcade of Discord)*, 1894.

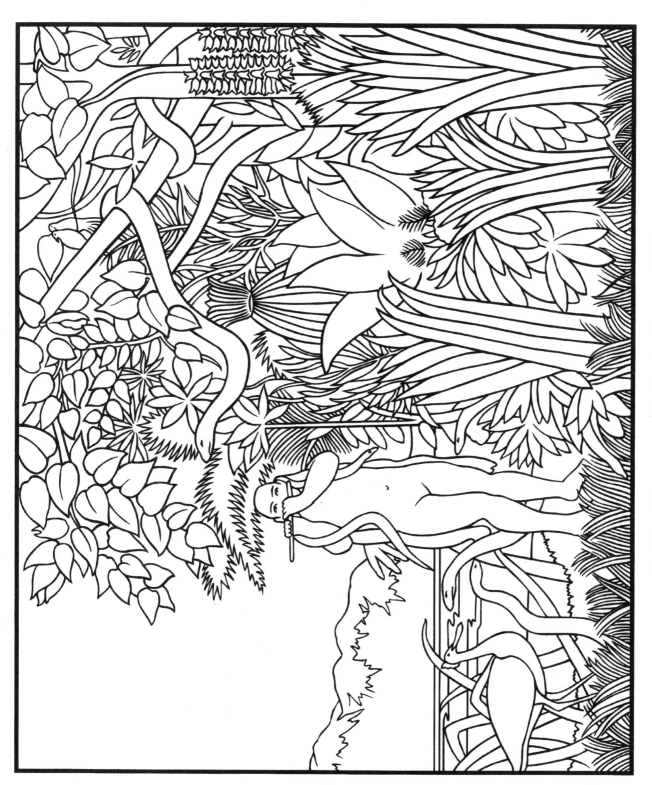

47. **Henri Rousseau.** *The Snake Charmer,* 1907.

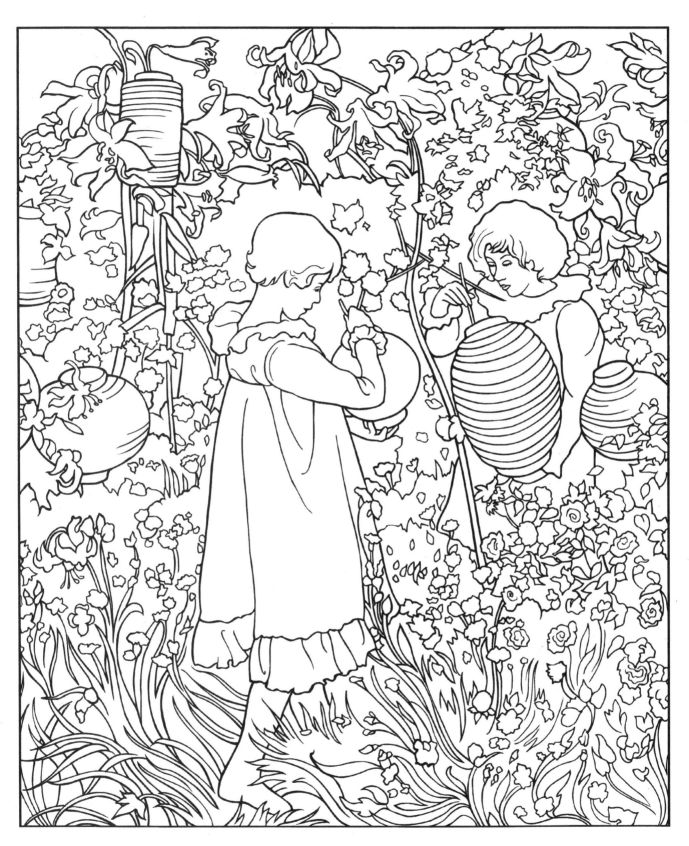

48. **John Singer Sargent.** *Carnation, Lily, Lily, Rose,* 1885.

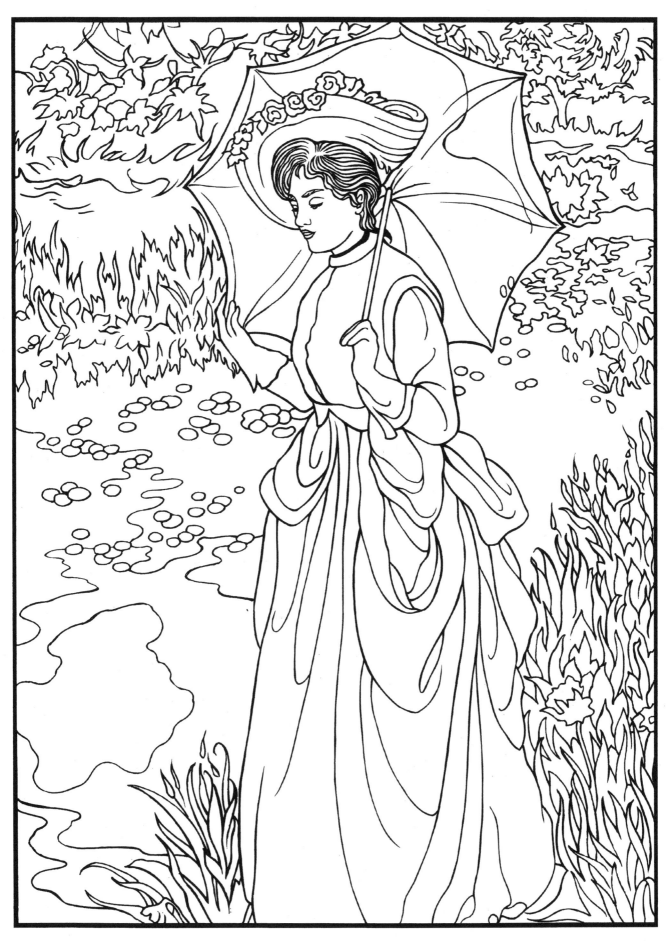

49. **John Singer Sargent.** *A Morning Walk,* 1888.

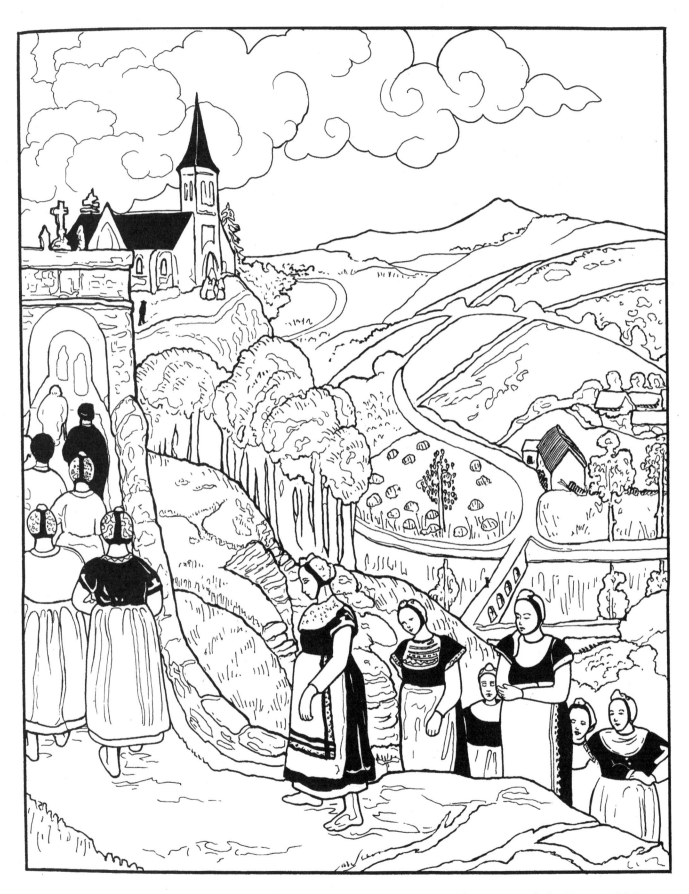

50. **Paul Sérusier.** *Le Pardon de Notre-Dame-de-Portes-à-Chateauneuf du Faou,* 1894.

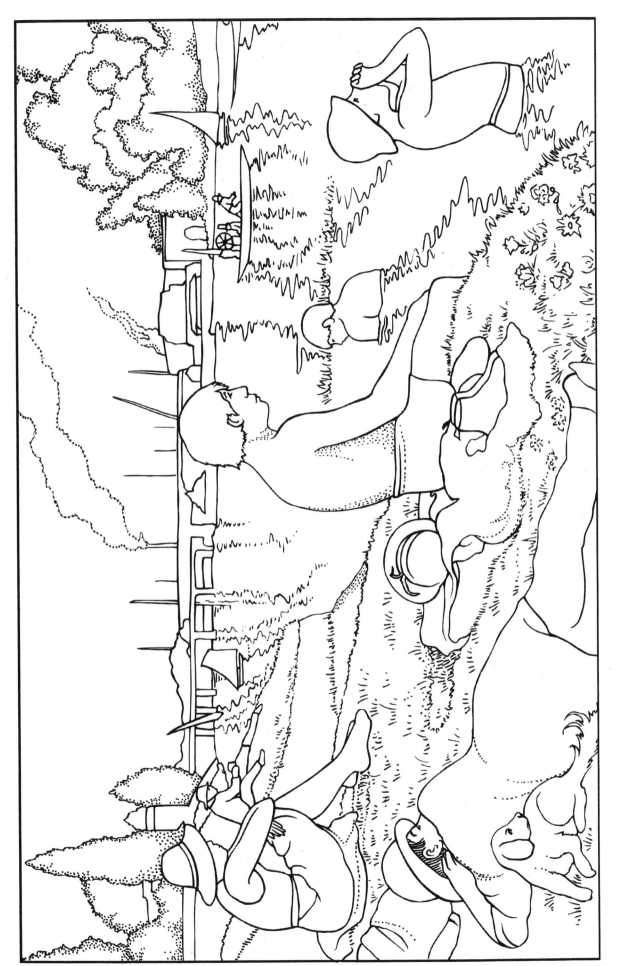

51. **Georges Seurat.** *Bathers at Asnières,* 1883–84.

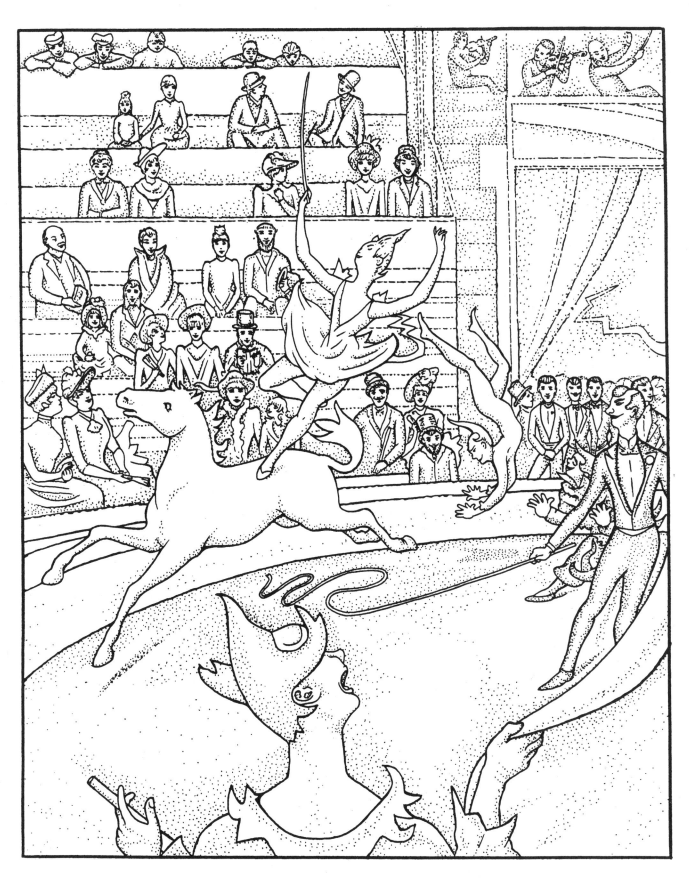

52. **Georges Seurat.** *The Circus,* 1890–91.

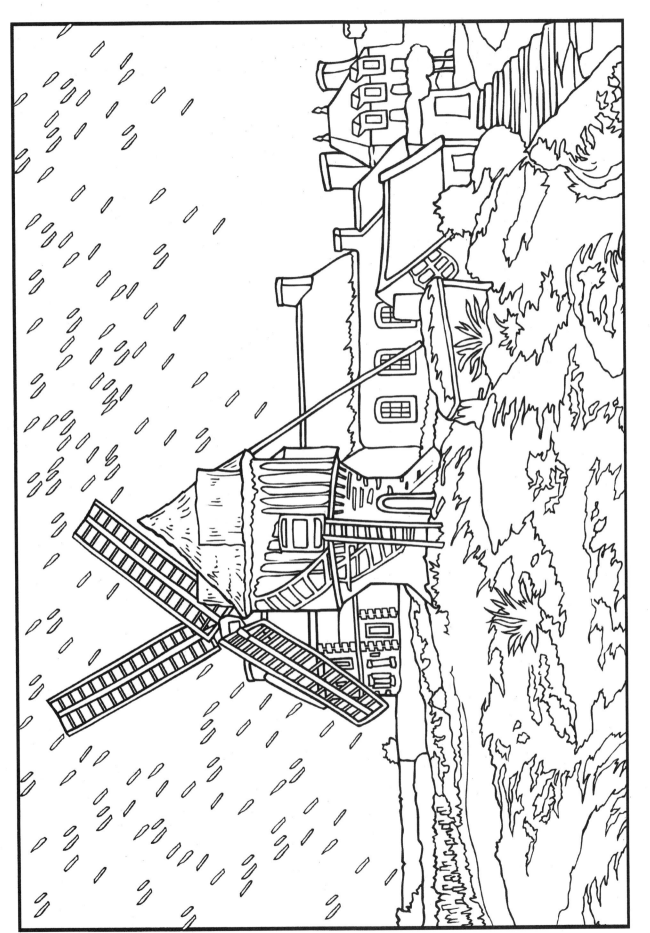

53. **Paul Signac.** *Le Moulin de Pierre Hâlé, Saint-Briac,* 1884.

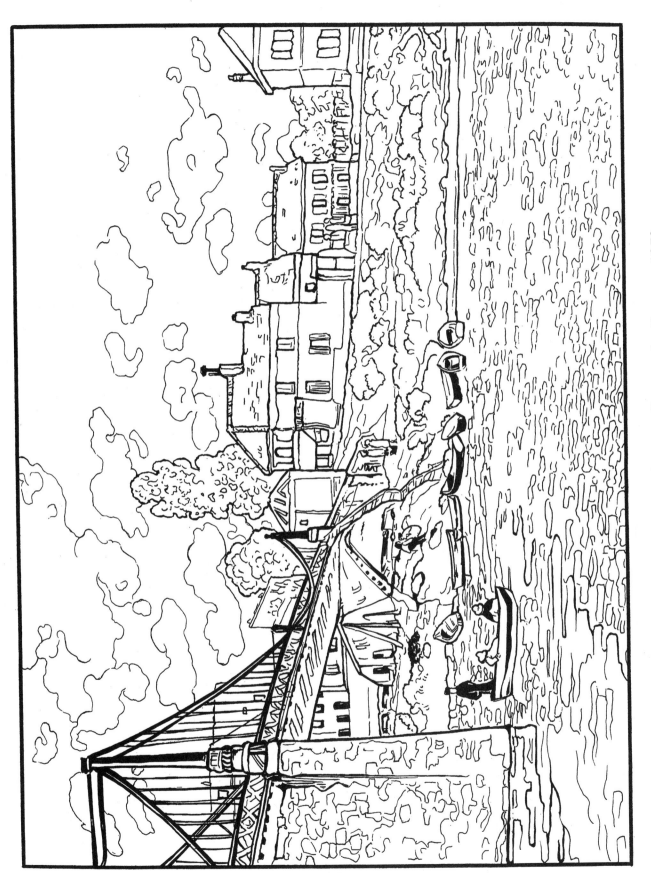

55. **Alfred Sisley**. *The Bridge at Villeneuve-la-Garenne, 1872.*

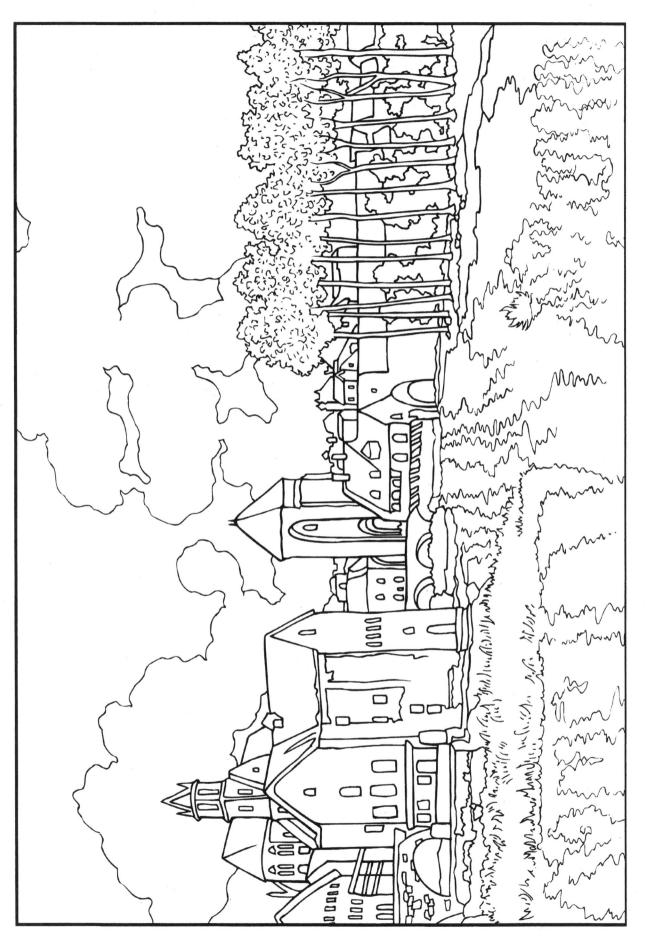

56. **Alfred Sisley.** *Moret-sur-Loing,* 1891.

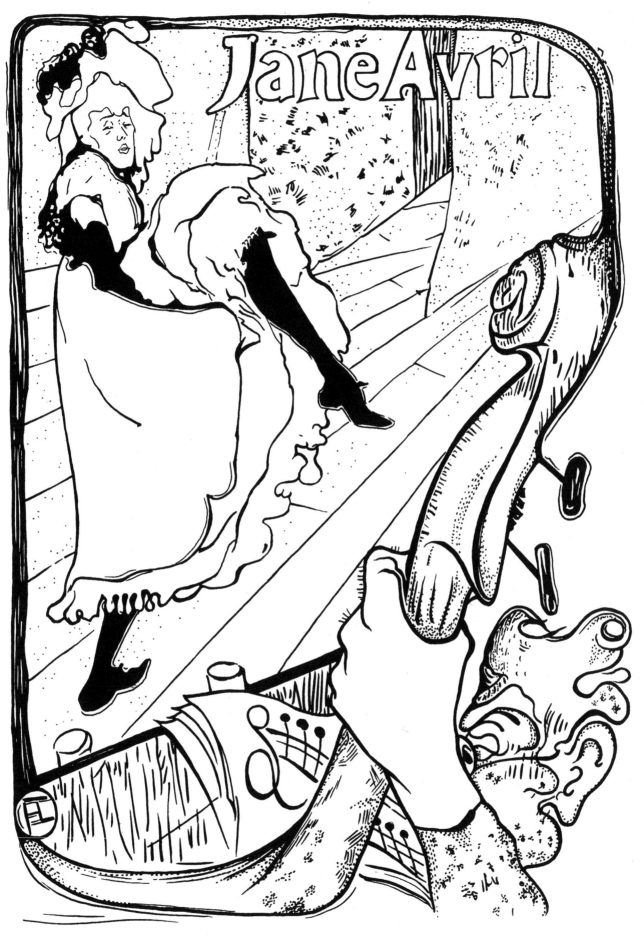

57. **Henri de Toulouse-Lautrec.** *Jane Avril,* 1893.

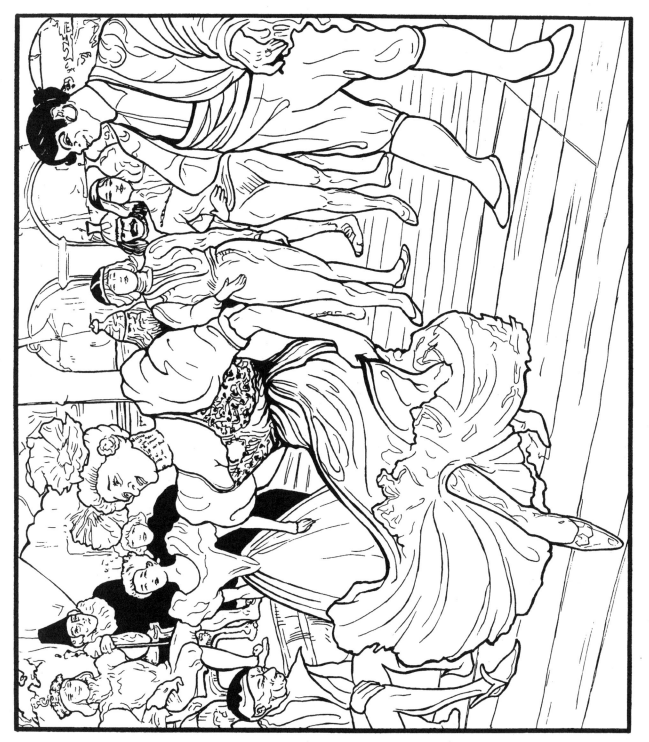

58. **Henri de Toulouse-Lautrec.** *Chilpéric (Mlle. Marcelle Lender Dancing the Bolero)*, 1896.

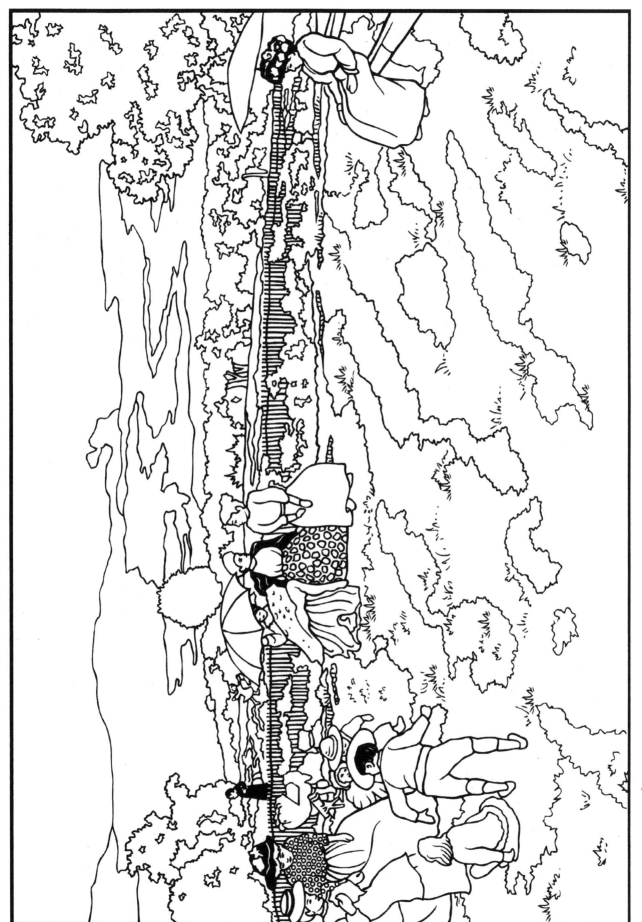

59. **Édouard Vuillard.** *Public Gardens: The Conversation; The Nursemaids; The Red Parasol,* 1894.

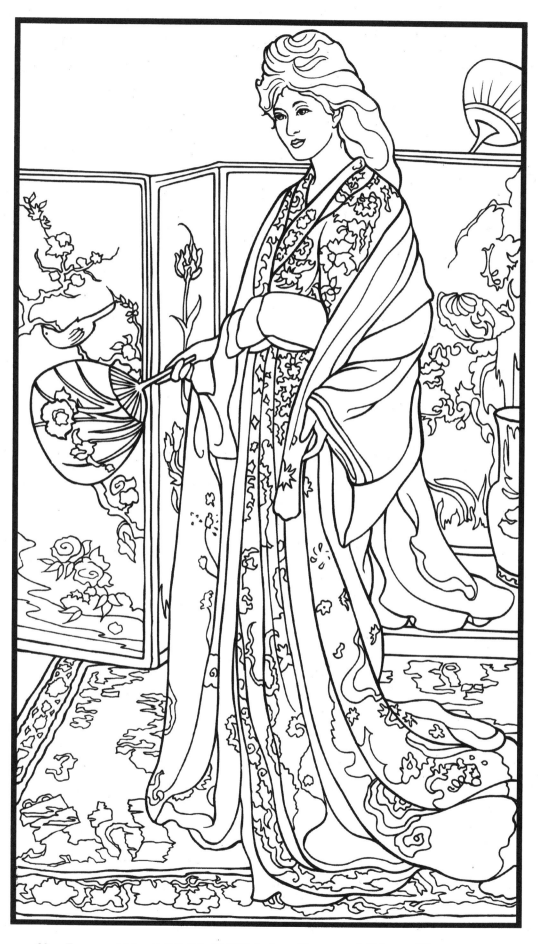

60. **James Abbott McNeill Whistler.** *Rose and Silver: The Princess from the Land of Porcelain,* 1864.

NOTES

1. Frédéric Bazille (1841–1870). *Flowers,* 1868. Oil on canvas, 51⅛ in. x 37⅜ in. Influenced by the work of the Barbizon school as well as that of Manet and Courbet, Bazille attended painting classes at Gleyre's studio while simultaneously studying medicine. Abandoning his medical studies soon after, he painted *en plein air* with Monet in the forest of Fontainebleau. Bazille shared a studio with both Renoir and Monet, and executed numerous portraits of his friends and family. He was also a fixture at the gatherings at the Café Guerbois, a hotspot for nineteenth-century painters. Using muted colors, Bazille's harmonious landscapes and family scenes made him one of the foremost representatives of early Impressionism.

2. Cecilia Beaux (1855–1942). *After the Meeting,* 1914. Oil on canvas, 40¹⁵⁄₁₆ in. x 28⅛ in. Cecilia Beaux was the daughter of a Frenchman and an American woman, who died only twelve days after her birth. Beaux was raised in Philadelphia by her maternal grandmother and two aunts. She learned sculpture at Adolf van der Whelen's Art School for Women, but was soon commissioned to paint children's portraits on plaques. Beaux's first major painting won the Mary Smith Award and was exhibited at the Pennsylvania Academy. In 1888, she traveled to Europe, attended the Académie Julian, and studied the old masters at the Louvre. Beaux moved her studio to New York in the 1890s and worked for the United States Portraits Commission after World War I.

3. Émile Bernard (1868–1941). *Breton Women in the Meadow,* 1888. Oil on canvas, 29⅛ in. x 36¼ in. French Symbolist painter Émile Bernard began his studies at the École des Beaux-Arts alongside artists Louis Anquetin and Toulouse-Lautrec. After his suspension from the school for insubordination, Bernard embarked on a tour of Brittany, where he drew artistic inspiration from both the landscape and the pure simplicity of Breton life. Bernard later originated what became known as *cloisonnisme,* a painting style characterized by dark outlines surrounding flat bright forms, as in *cloisonné* enamelwork. Counting Cézanne among his primary influences, Bernard also worked closely with Gauguin and van Gogh before joining Redon and Hodler to form a Symbolist group of painters.

4. Pierre Bonnard (1867–1947). *Bouquet of Flowers,* c. 1926. Oil on canvas, 27½ in. x 18¾ in. The son of a prominent official of the French Ministry of War, Bonnard studied law early in his life, serving a brief stint as a barrister. However, he had attended art classes on the side, and exhibited his work at the Salon des Artistes Indépendants before hosting his first show in 1896. Forming an association with Paul Sérusier and Édouard Vuillard at the Académie Julian in Paris, Bonnard became one of the Nabis, a group of artists dedicated to creating symbolic and spiritual works. After 1900, Bonnard reverted to a more naturalistic style, rooted in Impressionism. His later works have fluid brushstrokes and bright, intense colors.

5. Eugène Louis Boudin (1824–1898). *Princess Metternich on Trouville Beach,* 1869. Oil on panel, 11⅝ in. x 9⅝ in. French painter of seascapes and beach scenes, Boudin first exhibited his paintings in his framing shop in Le Havre. He recorded the changing skies and seas in numerous small paintings that influenced the Impressionists greatly, particularly Monet, who became his lifelong friend. The originality of Boudin's work is evident in his spontaneous, delicate brushwork. One of the first French landscape artists to paint outdoors, he exhibited his marine paintings at the first Impressionist Exhibition in 1874. During the 1870s through the 1890s, Boudin traveled extensively, to locales such as Belgium, the Netherlands, and Venice. In 1892, he was knighted in recognition of his talents and for how his work shaped the art of his contemporaries.

6. Gustave Caillebotte (1848–1894). *Oarsmen,* 1877. Oil on canvas, 37¾ in. x 45½ in. French artist Gustave Caillebotte painted exquisite landscapes and portraits, but was best known for his scenes of urban life and the new Parisian boulevards of the mid-nineteenth century. Although Caillebotte was an engineer by trade, he had studied art at the École des Beaux-Arts in Paris, where he met Renoir, Monet, and Degas. He displayed his works at the 1876 Impressionist Exhibition and eventually became the chief organizer, promoter, and financial patron for future shows. A substantial inheritance from his father enabled him to purchase paintings from Cézanne, Morisot, Pissarro, and others. He left this extensive collection of Impressionist paintings to the French government after his death.

7. Mary Cassatt (1844–1926). *The Bath,* 1891–92. Oil on canvas, 39½ in. x 26 in.

8. Mary Cassatt (1844–1926). *The Boating Party,* 1893–94. Oil on canvas, 35½ in. x 46⅛ in.

9. Mary Cassatt (1844–1926). *Mother Combing Her Child's Hair,* c. 1901. Pastel and gouache on tan paper, 25¼ in. x 31½ in. Born in Pennsylvania, Cassatt was the only American female member of the Impressionists. She studied art at the Pennsylvania Academy of Art and then traveled to Europe, spending most of her life in Paris.

Professionally, she was greatly influenced by her close friend, French Impressionist painter Edgar Degas. Cassatt painted family scenes of mothers and children, and achieved recognition for these tender representations. She was also very much influenced by Japanese woodcuts, and excelled in making woodcut prints. Her eyesight began to fail in 1900, and Cassatt stopped working by 1914.

10. Paul Cézanne (1839–1906). *Still Life with Compotier,* 1879–82. Oil on canvas, 18⅛ in. x 21⅝ in.

11. Paul Cézanne (1839–1906). *The Sea at L'Estaque,* 1883–86. Oil on canvas, 28¾ in. x 36¼ in.

12. Paul Cézanne (1839–1906). *The Cardplayers,* 1890–92. Oil on canvas, 52¾ in. x 71½ in. French Post-Impressionist painter Paul Cézanne was the only son of a wealthy banker. His early works had a dark, somber tone that brightened after he began to paint outdoors with Pissarro in 1872. Dissatisfied with the Impressionists' sole reliance on light effects, Cézanne concentrated on the use of geometric form and construction. A prime influence on twentieth-century art, notably Cubism, Cézanne created effects of depth and solidity by varying the interaction of planes of paint, parallel brushstroke, and intense color. His compositions include portraits of himself and his family, over 200 still lifes, and many variations of L'Estaque and Mont Sainte-Victoire landscapes.

13. William Merritt Chase (1849–1916). *At the Seaside,* 1892. Oil on canvas, 20 in. x 34 in. Born in Indiana, Chase is best known for his portraits, landscapes, and still lifes. With the assistance of local patrons, he enrolled at the Royal Academy in Munich, where he acquired a dark, somber palette. A tour in Venice turned his interest toward the impressionistic effects of light, and his landscapes soon began to reflect this influence. Chase is renowned for his landscapes of Prospect Park in Brooklyn, Central Park in Manhattan, and his scenes from his summer home on Shinnecock, Long Island. For nearly forty years, Chase taught at a variety of art academies, including the Art Students League, where he touched the lives of such pupils as Edward Hopper, Charles Sheeler, and Georgia O'Keeffe.

14. Edgar Degas (1834–1917). *A Woman with Chrysanthemums,* 1865. Oil on canvas, 29 in. x 36½ in.

15. Edgar Degas (1834–1917). *Monsieur Perrot's Dance Class,* c. 1875. Oil on canvas, 33½ in. x 29½ in.

16. Edgar Degas (1834–1917). *The Absinthe Drinker,* 1876. Oil on canvas, 36¼ in. x 26¾ in. Born in Paris, France, Degas taught himself to paint by copying the old masters in the Louvre. He enrolled at the École des Beaux-Arts and began to take an interest in painting modern life subjects. Degas painted the subtle movements of musicians, ballet dancers, and other stage performers in elegant, painstaking detail. These kinds of subjects afforded him the opportunity to depict fleeting moments in time and unusual angles. Akin to the view through the lens of a camera, Degas's paintings are infused with novel, unique perspectives that have come to epitomize his work.

17. Maurice Denis (1870–1943). *Paradise,* 1912. Oil on canvas, 19¾ in. x 29½ in. One of the original founding members of the Nabis, a Symbolist group of painters, the French-born Denis enrolled at the Académie Julian in 1888 and then attended the École des Beaux-Arts, where he encountered Sérusier. In 1919, Denis helped to establish the Studios of Sacred Art, which dedicated itself to the revival of religious painting. He also designed stained glass and mosaic panels, ceramics, and completed a decorative painted ceiling for the French composer Chausson. In addition to his work as an artist, Denis wrote several critical art theories, which greatly contributed to the progress of modern art, notably Cubism, Fauvism, and abstract art.

18. André Derain (1880–1954). *La Danse,* 1906. Oil on canvas, 72⅞ in. x 90½ in. A major exponent of the Fauvist movement, Derain was born in Chatou, France. He was most closely associated in style to Matisse and Vlaminck, with whom he shared a studio. Derain was one of the first artists to collect African art, which became a key source of inspiration for many early-twentieth-century artists. Influenced by the work of Cézanne as well as the early Cubist paintings of Picasso and Braque, Derain continued to experiment with different compositional techniques. Typically, Derain's Fauvist paintings are full of intense, bold colors, but after studying the old masters in 1912, his style grew more traditional and structured. He also designed sets and costumes for the Diaghilev ballet, executed a number of sculptures, and illustrated several books.

19. Paul Gauguin (1848–1903). *Breton Girls Dancing, Pont-Aven,* 1888. Oil on canvas, 28¾ in. x 36½ in.

20. Paul Gauguin (1848–1903). *Self-Portrait with Halo,* 1889. Oil on wood, 31⅜ in. x 20⅜ in.

21. Paul Gauguin (1848–1903). *Tahitian Women (On the Beach),* 1891. Oil on canvas, 27¼ in. x 36 in. A major precursor of modern art, French artist Paul Gauguin pioneered an appreciation of the simple and primitive in art. Generally regarded as one of the greatest of the Post-Impressionists, he depicted peasant life in Brittany early in his career and spent the last ten years of his life painting in Tahiti and the Marquesas Islands. His Breton style, characterized by flat contoured figures, gradually matured into the richly colored works of his later South Seas period. His Tahitian works—among his most famous—are comprised of native figures and landscapes with strong outlines and flat, bold colors.

22. Vincent van Gogh (1853–1890). *Fishing in the Spring, Pont de Clichy,* 1887. Oil on canvas, 19¼ in. x 22⅛ in.

23. Vincent van Gogh (1853–1890). *Self-Portrait with Bandaged Ear and Pipe,* 1889. Oil on canvas, 20⅛ in. x 17¾ in.

24. Vincent van Gogh (1853–1890). *Village Street in Auvers,* 1890. Oil on canvas, 28¾ in. x 36¼ in. The Dutch Post-Impressionist painter tried such varied careers as language teacher, art dealer, and preacher before he began to paint in earnest in 1880. Expressive brushwork, the heightened use of color, and an intense emotionality typify

van Gogh's unique style. His attempt to organize an artists' community in Arles with Toulouse-Lautrec and Gauguin proved to be unsuccessful. Van Gogh's volatile career lasted merely one decade; he took his own life in 1890. Although he sold just one painting during his lifetime, van Gogh produced 800 oil paintings and 700 drawings.

25. Jean-Baptiste Armand Guillaumin (1841–1927). *Still Life; Flowers, Faïence, Books,* 1872. Oil on canvas, 13 in. x 18 in. Largely self-taught, Guillaumin worked at his uncle's fashion store in Paris before attending the Académie Suisse, where he encountered Pissarro and Cézanne. While working with Pissarro in the open air, Guillaumin painted numerous landscapes in lively colors using broad brushstrokes. He took part in several Impressionist exhibitions and was introduced to the American Impressionist circle through the New York art dealer Durand-Ruel. Though he was not an innovator of an art style himself, Guillaumin was very receptive to new ideas and encouraged many up-and-coming artists, including Signac.

26. Childe Hassam (1859–1935). *Flower Girl,* 1888. Oil on canvas, 14¼ in. x 8⅝ in. A notable figure in the American Impressionist movement, Hassam was called the "American Monet." In his mature works, the brush-work is loose and delicate and the color much brighter and richer than in his earlier style. He often drew scenes straight from the streets of New York City, successfully capturing the vital atmosphere. Along with fellow artists such as John Twachtman and William Merritt Chase, Hassam formed the loose association known as The Ten American Painters. The annual exhibitions held by The Ten greatly encouraged the spread of Impressionism and helped carry the art style well into the twentieth century.

27. Édouard Manet (1832–1883). *Peonies in a Vase on a Stand,* 1864. Oil on canvas, 37 in. x 27½ in.

28. Édouard Manet (1832–1883). *Argenteuil,* 1874. Oil on canvas, 58½ in. x 45¼ in. French painter and printmaker Édouard Manet was the son of a high-ranking government official who denounced Manet's inclination toward art. Although Manet's art was strongly rooted in the classics, he was often criticized for his modernity. The Salon rejected several of his paintings due to their controversial subjects. Having adopted the style of painting out-of-doors, Manet was a greatly respected practitioner of Impressionism, though he did not participate in the official exhibitions of the group. Manet was one of the first nineteenth-century painters to spurn academic formulae and subjects in favor of the depiction of contemporary life.

29. Willard Metcalf (1858–1925). *Gloucester Harbor,* 1895. Oil on canvas, 26 in. x 28¾ in. Born in Lowell, Massachusetts, Willard Metcalf attended classes at the Boston Museum of Fine Arts as well as the Académie Julian in Paris. While abroad, he spent time in the art colonies at Grez-sur-Loing and Pont-Aven in France, and was one of the first Americans to go to Giverny, where Claude Monet had a home and gardens. In 1896, Metcalf

won the Webb Prize at the Society of American Artists' Annual Exhibition for *Gloucester Harbor,* the painting shown here. With a blend of realism and French Impressionism, his luminous representations of New England landscapes showcase his skill in depicting the play of sunlight on the countryside.

30. Paula Modersohn-Becker (1876–1907). *Seated Naked Girl with Flowers,* 1907. Oil on canvas, 35 in. x 43 in. Modersohn-Becker was a German painter who adapted the Post-Impressionist style of Parisian art into her own work. She attended professional art schools and lived in an artists' colony in Germany. After 1900, Modersohn-Becker traveled to Paris to study French avant-garde painting and attended classes at the École des Beaux-Arts, which first opened its doors to women in 1897. Like Cassatt, she used the mother and child theme in a few of her paintings. Modersohn-Becker died at the age of thirty-one, shortly after giving birth to her first child.

31. Claude Monet (1840–1926). *Le Déjeuner sur l'herbe (Luncheon on the Grass),* 1865–66. Oil on canvas, 97⅝ in. x 85½ in.

32. Claude Monet (1840–1926). *Terrace at Sainte-Adresse,* 1867. Oil on canvas, 38½ in. x 51 in.

33. Claude Monet (1840–1926). *Water Lilies I,* 1905. Oil on canvas, 35¼ in. x 39⅜ in. Leading French Impressionist Claude Monet was introduced to the *plein air* style of painting in the 1860s by Boudin. Monet sought to record the "impression" that the subject gave the viewer at that precise time of day, effectively capturing the transient effects of light. Beginning in 1890, he embarked on a series of works that studied the same subject under different light conditions. These works include *Haystacks* and *Water Lilies,* both of which express the subtle nuances of color, light, and atmosphere.

34. Berthe Morisot (1841–1895). *Hide and Seek,* 1873. Oil on canvas, 17¾ in. x 21⅝ in.

35. Berthe Morisot (1841–1895). *In the Dining Room,* 1886. Oil on canvas, 24⅛ in. x 19¾ in. Born in Bourges, France, Morisot was the daughter of a high-ranking government official and granddaughter of the Rococo painter Jean-Honoré Fragonard. As a child, she knew she wanted to be an artist, and learned to draw by copying works in the Louvre with her sister. Exhibiting regularly with the Impressionists, Morisot was influenced by the work of Édouard Manet, and eventually married his younger brother, Eugène, in 1874. Her paintings usually depicted members of her family, including her daughter, Julie. Among her closest friends were Degas, Renoir, and Monet.

36. Camille Pissarro (1830–1903). *Chestnut Trees at Louveciennes,* c. 1872. Oil on canvas, 16⅛ in. x 21¼ in.

37. Camille Pissarro (1830–1903). *Still Life with Apples and Pitcher,* 1872. Oil on canvas, 18¼ in. x 22¼ in. One of the founders of Impressionism, Pissarro studied art in Paris, where he was first attracted to the works of the

Barbizon school and the realism of Corot. In the 1860s and 1870s, Pissarro lightened his palette and applied brushstrokes of bright color on his canvases to create luminous effects. Along with fellow Impressionist painters Monet, Renoir, and Manet, Pissarro helped organize the first independent Impressionist exhibition in 1874. He also experimented with various artistic styles, such as Pointillism, a technique popularized by Seurat.

38. Lucien Pissarro (1863–1944). *Jeanne*, 1889. Oil on canvas, 28¾ in. x 23¼ in. French painter and engraver Lucien Pissarro was the eldest son of Impressionist painter Camille Pissarro. While growing up, he experienced the beginnings of the Impressionist movement firsthand, and was encouraged to paint by his father and his father's contemporaries, among them Monet, Cézanne, and Manet. The younger Pissarro exhibited some of his works, along with his father, at the last Impressionist Exhibition of 1886. Both generations of Pissarros had longstanding friendships with Signac and Seurat, and Lucien's work began to display elements of their Divisionist approach. He moved to England in 1890, where he founded the Eragny Press, which published limited editions of illustrated books.

39. Maurice Prendergast (1859–1924). *Central Park*, c. 1908–10. Oil on canvas, 20¾ in. x 27 in. Born in St. John's, Newfoundland, Canada, Maurice Prendergast grew up in Boston, and returned there as an adult to set up an art studio. In the early 1890s, he traveled abroad to study art in both Paris and Italy and was particularly inspired by Post-Impressionism. He developed his own signature style of blocks of color and dark outlines, creating mosaic or stained glass-like effects in his paintings and watercolors. *Central Park* is a typical example of the artist's many scenes of people gathered in New York or by the seaside.

40. Pierre Puvis de Chavannes (1824–1898). *The Poor Fisherman*, 1881. Oil on canvas, 61 in. x 76 in. The leading French mural painter of the latter half of the nineteenth century, Pierre Puvis de Chavannes studied under Eugène Delacroix and Thomas Couture. While he painted in oil, his finished works had pale, subdued colors, giving the impression of an Italian fresco painting. His mural commissions included pieces for such public buildings as the Sorbonne, the Paris City Hall, the Pantheon in Paris, and the Boston Public Library. His work is often categorized as Symbolist in nature and his allegorical representations of abstract themes held considerable appeal to both the Post-Impressionists and the Symbolists. Gauguin, Seurat, Toulouse-Lautrec, and Rodin were among his most devoted admirers.

41. Odilon Redon (1840–1916). *The Buddha*, c. 1906–07. Pastel, 35½ in. x 28¾ in. The greatest of the French Symbolists, Odilon Redon worked almost exclusively in charcoal until his fifties. During the 1890s, he took up painting in pastels and color. After a religious crisis in the early 1890s and a serious illness in 1894–95, the previously unhappy Redon was transformed into a more cheerful personality and expressed himself using radiant colors in mythological scenes and flower paintings. His flower pieces in particular were very much admired by Matisse, and the Surrealists regarded Redon as one of their precursors.

42. Pierre-Auguste Renoir (1841–1919). *Girl with a Watering Can*, 1876. Oil on canvas, 39½ in. x 28¾ in.

43. Pierre-Auguste Renoir (1841–1919). *By the Seashore*, 1883. Oil on canvas, 36¼ in. x 28¾ in.

44. Pierre-Auguste Renoir (1841–1919). *Girls at the Piano*, 1892. Oil on canvas, 45½ in. x 35½ in. Born in France, Renoir began his art career with an apprenticeship at a factory, where he painted flowers onto porcelain dishes. Along with fellow Impressionist painters Sisley, Bazille, and Monet, Renoir painted landscapes directly from nature to study the effects of light. Using feathery brushstrokes and sparkling bursts of color, Renoir painted over 2,000 portraits in his lifetime. Among his favorite subjects were portraits of women, children, and social scenes of everyday life.

45. Theodore Robinson (1852–1896). *La Débâcle*, 1892. Oil on canvas, 18 in. x 22 in. Of all the American Impressionists, Theodore Robinson shared the closest friendship with Claude Monet. A mutual admiration linked the two artists, who regularly visited each other's studios while Robinson was abroad. Born in Vermont but raised in Wisconsin, Robinson studied at the Art Institute of Chicago, the National Academy of Design, and the Art Students League, before moving to France, where he lived from 1876 to 1892. Two of his Impressionist paintings won esteemed public honors; one was bestowed the coveted Webb Prize in 1890, and a second one the Shaw Fund Prize the following year. In 1893, he returned to America, settling first in New York, then in Connecticut. He worked as an art instructor before his premature death at forty-three from chronic asthma. His work successfully blends American realism with the Impressionists' perception of light effects.

46. Henri Rousseau (1844–1910). *War (Cavalcade of Discord)*, 1894. Oil on canvas, 42 in. x 76¾ in.

47. Henri Rousseau (1844–1910). *The Snake Charmer*, 1907. Oil on canvas, 66½ in. x 74½ in. A customs officer who painted in his spare time, the French-born Rousseau had no formal artistic training and only devoted himself exclusively to painting after his early retirement at the age of forty. Renowned for his highly stylized works, Rousseau created detailed paintings of lush foliage and mysterious figures in exotic imaginary landscapes. His portraits, still lifes, and junglescapes are initial examples of a manner of painting known as "naïve," a term indicative of the way an artist treated a subject in his or her own visionary way.

48. John Singer Sargent (1856–1925). *Carnation, Lily, Lily, Rose*, 1885. Oil on canvas, 68½ in. x 60½ in.

49. John Singer Sargent (1856–1925). *A Morning Walk*, 1888. Oil on canvas, 26⅜ in. x 19¾ in. Portrait painter John Singer Sargent was born in Florence, Italy, to American parents. As a youngster, Sargent traveled with his parents

around Europe, and gained experiences that would contribute greatly to his self-assurance with all kinds of people and places. Exquisite portrayals of affluent figures of the day and their families made Sargent a much sought-after artist, and many patrons clamored for his refined, flattering style. Sargent went through a brief Impressionist phase, inspired by the work of Claude Monet at Giverny.

50. Paul Sérusier (1864–1927). *Le Pardon de Notre-Dame-de-Portes-à-Chateauneuf de Faou,* 1894. Oil on canvas, 36¼ in. x 28¾ in. French Post-Impressionist and theorist Paul Sérusier was one of the co-founders of the Symbolist Nabis in the 1890s. A student of philosophy, Sérusier decided to become an artist and enrolled at the Académie Julian in Paris. He met Gauguin in Brittany at Pont-Aven in 1888, painting for a time in the manner of Synthetism. In 1897, he joined the school of religious art at the Benedictine abbey of Beuron in Germany. Powerfully affected by their themes of religious symbolism and proportions, Sérusier gravitated toward a mystical conception of art. He published his *ABC of Painting* in 1921, which concerned systems of proportion and color relationships.

51. Georges Seurat (1859–1891). *Bathers at Asnières,* c. 1883–84. Oil on canvas, 79⅛ in. x 118¾ in.

52. Georges Seurat (1859–1891). *The Circus,* 1890–91. Oil on canvas, 73 in. x 60 in. Using newly discovered color theories, Post-Impressionist painter Georges Seurat painted his subject by placing tiny, precise brushstrokes of color close to one another so that the viewer's eye blends them at a distance. This technique is known as *Pointillism.* The artist drew many different versions of his paintings, and would complete more than thirty oil sketches to prepare for the final work. His painstaking method is often contrasted with the spontaneity of the Impressionists.

53. Paul Signac (1863–1935). *Le Moulin de Pierre Hâlé, Saint-Briac,* 1884. Oil on canvas, 23⅝ in. x 36¼ in.

54. Paul Signac (1863–1935). *Two Milliners, Rue de Caire,* c. 1885–86. Oil on canvas, 44 in. x 35 in. Originally intending to be an architect, Signac began to paint under the guidance of Monet and Guillaumin in 1880. Along with Seurat, Signac co-founded the Salon des Artistes Indépendants in 1884, and helped to further develop the Pointillist style of painting. The two artists began to fill their canvases with tiny dots of pure color using a precise, geometrical system rather than the previous methods employed by the early Impressionists. Signac was present at the Eighth Impressionist exhibition and also exhibited his works with Durand-Ruel in New York. He kept in close touch with fellow artists such as Pissarro and van Gogh, and also wrote articles on art criticism.

55. Alfred Sisley (1839–1899). *The Bridge at Villeneuve-la-Garenne,* 1872. Oil on canvas, 19½ in. x 25¾ in.

56. Alfred Sisley (1839–1899). *Moret-sur-Loing,* 1891. Oil on canvas, 25½ in. x 36¼ in. An originator of French Impressionism, Alfred Sisley was born in Paris, the son of well-to-do English parents living in France. From 1857 to

1862, he studied in London, where his interest in art blossomed. Returning to Paris, Sisley entered the studio of Charles Gleyre, where he engendered friendships with Monet, Bazille, and Renoir. He painted landscapes almost exclusively, paying unusual attention to detail and light effects. His snowscapes exhibit a distinctive harmony and serenity. The sunlit painting of *Moret-sur-Loing* illustrates the effectiveness of executing landscapes directly on the canvas while outdoors.

57. Henri de Toulouse-Lautrec (1864–1901). *Jane Avril,* 1893. Color lithograph, poster, 48¾ in. x 36 in.

58. Henri de Toulouse-Lautrec (1864–1901). *Chilpéric (Mlle. Marcelle Lender Dancing the Bolero),* 1896. Oil on canvas, 60⅝ in. x 59 in. French painter and graphic artist Toulouse-Lautrec began to paint while recuperating from crippling injuries to his legs. In 1884 he established a studio in the Montmartre district of Paris, beginning a lifelong association with the area's cafés, cabarets, and entertainers. Noted for his satiric sketches and studies of Parisian nightlife, he exerted a tremendous influence on future artists. Toulouse-Lautrec stands as an innovator, known for his posters and lithographs of individuals from the "seedier" side of life. By simplifying outlines and juxtaposing intense colors, he effortlessly conveys the impression of movement in his subjects.

59. Édouard Vuillard (1868–1940). *Public Gardens: The Conversation; The Nursemaids; The Red Parasol,* 1894. Three panels: 83¾ in. x 61 in.; 84 in. x 28¾ in.; 84 in. x 32 in. A co-founder of the Nabis, the Symbolist group of painters, Édouard Vuillard shared a studio with Bonnard and Denis. Strongly influenced by the work of Degas, Redon, and Gauguin, Vuillard carefully studied the canvases of the Impressionists. His garden scenes owe a great debt to the early paintings of Monet in his use of dappled sunlight. The sudden popularity of Japanese woodcuts had a profound effect on his compositions as well. Vuillard is best known, however, for his paintings of interiors, the bulk of which are impressively decorative domestic scenes executed with a keen sense of light and color.

60. James Abbott McNeill Whistler (1834–1903). *Rose and Silver: The Princess from the Land of Porcelain,* 1864. Oil on canvas, 78¾ in. x 45⅝ in. American painter and etcher James Abbott McNeill Whistler was born in Lowell, Massachusetts. He spent his childhood in Russia, where his father worked as a civil engineer. In 1855, Whistler traveled to Paris to study art and remained in Europe for the rest of his life. During the 1860s, Whistler developed a fascination with Japanese art, and began to incorporate Oriental fans and blossoms into his paintings. A propagandist of the "art for art's sake" philosophy, Whistler believed that painting should exist for its own sake without conveying literary or moral ideas. In his later years, Whistler, who worked in watercolors, pastels, and executed more than fifty etchings, came to be regarded as a major artist of refreshing originality as well as a champion of modern art.